IMAGES
of America

PENDLETON

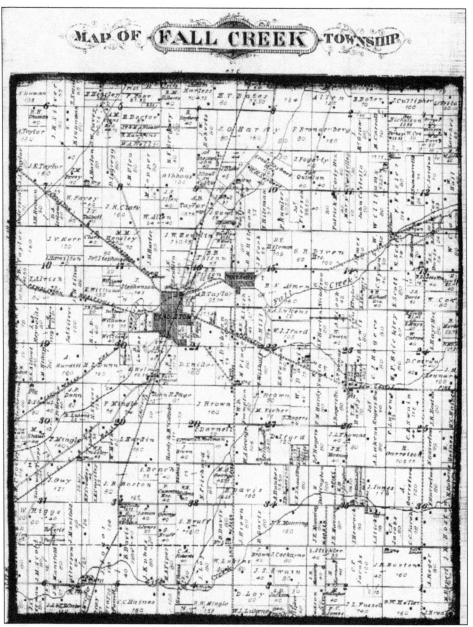

MAP OF FALL CREEK TOWNSHIP

This map shows how Fall Creek Township looked in 1872. Near the center of the map is the town of Pendleton, established in 1820. (Madison County Historical Society.)

ON THE COVER: A group of people sit near the falls during the early part of the 20th century. In 1821, Thomas McCartney built the first mill on the south side of the creek at the falls. Until that time, the closest mill for grinding corn was in the city of Connersville. By 1925, McCartney had enlarged the mill with the equipment needed to grind both corn and wheat. In 1850, James M. Irish built a woolen mill on the north side of the stream below the falls. This mill burned down and was replaced by a four-story, brick and stone woolen mill. In 1870, that structure was converted into a flour mill. Pendleton was an important milling center until 1904, when the last mill burned. (Pendleton Historical Museum.)

IMAGES
of America

PENDLETON

David Humphrey

ARCADIA
PUBLISHING

Published by Arcadia Publishing
Charleston, South Carolina

Library of Congress Control Number: 2017936375

For all general information, please contact Arcadia Publishing:
Telephone 843-853-2070
Fax 843-853-0044
E-mail sales@arcadiapublishing.com
For customer service and orders:
Toll-Free 1-888-313-2665

Visit us on the Internet at www.arcadiapublishing.com

CONTENTS

ACKNOWLEDGMENTS

This book would not have been possible without the photographs, historical information, and personal stories provided to me by the townspeople of Pendleton. To them, I am very grateful. Thanks to the Anderson Public Library, Pendleton Community Public Library, Pendleton Lions Club, Pendleton Kiwanis Club, Madison County Historical Society, South Madison Community Foundation, Indiana State Police Museum, Indiana Basketball Hall of Fame, Anderson *Herald Bulletin*, Pendleton Heights High School, and the Pendleton Indiana State Police Post. Special thanks to volunteers at the Pendleton Historical Museum, who granted me full access to the collection of artifacts, displayed and stored, in that treasured institution.

Unless otherwise noted, all images are courtesy of the Pendleton Historical Museum.

INTRODUCTION

The history of Pendleton, Indiana, dates to the early 1800s. On December 29, 1818, John Rogers settled near the falls, making him the first white settler in the area. Fall Creek was a natural attraction to early settlers, including Rogers, who built his home near the falls on the creek. The falls provided fresh water, as well as a source of power through the use of water wheels and grindstones. The powerful falls brought not only farmers into the area but also businessmen and craftsmen. In the spring of 1820, Elias Hollingsworth arrived in Pendleton with his wife, Elizabeth, who is considered to be the first white woman in Madison County. That same year, Elizabeth Hollingsworth gave birth to a son, Elias Pierce, the first white child born in the township. By 1825, an estimated 50 families took up residence along Fall Creek, one being the family of Thomas Pendleton, for whom Pendleton is named. Shrewd but generous, Pendleton had his land surveyed and divided into town lots. This led to the establishment of the town that bears his name. Two years later, Thomas Pendleton and his wife, Mary, donated land for the Methodist Episcopal Church, the first church built in Madison County.

In the early 1800s, a group of Quakers arrived from Pennsylvania and settled near Spring Valley, an area east of Pendleton. The Quakers brought with them their beliefs against slavery, the right to bear arms, and the mistreatment of Native Americans. Solomon Fussell, Neal Hardy, John and Elizabeth Rogers, and William Williams were among this group of early settlers. The Fall Creek Meeting House, constructed in 1836, became a landmark in the Underground Railroad movement. The meeting house was one of the stations on the Underground Railroad that helped many slaves find a path to freedom.

In December 1824 and spring of 1825, three white men were hanged near Fall Creek for the killing of nine Native Americans. The hideous murders became known as the Fall Creek Massacre. One of the assailants, Thomas Harper, had a deep-seated hatred for Indians and felt that the Native Americans had no place on his land. In February 1824, Harper led John Bridge Sr., James Hudson, and Andrew Sawyer to the Indian camp, where the slaughter took place. Bridge, Hudson, and Sawyer were found guilty and hanged for committing the crime. Though Harper instigated and partook in the murders, he escaped and was never apprehended.

In 1843, abolitionist Frederick Douglass spoke in Pendleton and was attacked by an angry white mob. Years later, Douglass returned to Madison County and forgave his attackers in a heartfelt speech delivered in the city of Anderson, Indiana. On February 10, 1841, the first Masonic lodge in Madison County was organized in Pendleton, followed by the county's first Odd Fellows lodge on September 11, 1850.

The 19th century also found Pendleton placed at a key junction of an interurban line running from Muncie to Indianapolis. Trains carrying passengers and freight ran down the center of what is now known as Pendleton Avenue. Though the interurban served its purpose as a rapid means of transportation, it was doomed with the coming of the automobile. On Saturday, January 18, 1941, the line through Pendleton ceased operation forever.

During the 1930s, the Pendleton Post Office, Pendleton Indiana State Police Post, and Pendleton High School were made possible through Pres. Franklin Roosevelt's Works Progress Administration. L. Keith Bulen, a 1944 graduate of Pendleton High School, went on to a successful career in politics, most notably as commissioner of the International Joint Commission under Pres. Ronald Reagan. Pendleton's own Don Hankins pitched one season for the Detroit Tigers. His Major League debut and final appearance both occurred in 1927. Hankins finished the season with a record of two wins and one loss. In 1947, the Pendleton High boys' basketball team was the talk of the town. The Fighting Irish were champions at the Anderson Sectional and the Indianapolis Regional basketball tournaments before losing a close game at the Indianapolis Semi-State tournament.

Public Enemy No. 1 John Dillinger spent time at the Indiana State Reformatory in Pendleton and played on the prison's baseball team. In 1924, Dillinger was arrested for robbing a Mooresville grocery store and found guilty of the crime. The court threw the book at Dillinger, sentencing him to 10 to 20 years at the reformatory in Pendleton. After serving eight years of his sentence, Dillinger was transferred to the Indiana State Prison in Michigan City. It was also at the reformatory that Thomas R. White founded a school where prisoners could receive an education and diploma. In later years, White acknowledged that educating prisoners was one of the highlights of his life.

In 1960, Massachusetts senator John F. Kennedy paid a visit to Pendleton while campaigning for the presidency. Pendleton High graduate Mike Hanna is the only athlete from the school to ever win a state championship. He accomplished the feat in the pole-vault, where he was the first high school athlete to ever vault 14 feet.

The town of Pendleton celebrated its 150th birthday in September 1970 with parades, music, foods, and historic reenactments. Upon graduating from Pendleton Heights High School in 1974, George Daugherty founded the Pendleton Symphony Orchestra and served as its conductor. A grassroots movement led by local townspeople resulted in the Pendleton Historical Museum. Dedication of the museum took place on September 5, 1981, with guest speaker Jessamyn West, author of *The Massacre at Fall Creek*. The Pendleton Heights Pendletones performed "Down by the Old Mill Stream" at the event, the official song of Pendleton.

A dedicated group of local women led a campaign to preserve Pendleton's history. After establishing Historic Fall Creek, Pendleton Settlement in 1988, members of the organization felt the need to take their love of Pendleton one step further. With the help of community leaders and other town and rural residents, Pendleton was listed in the National Register of Historic Places on June 27, 1991.

Good towns do not just happen. They become good towns through the hard work, dedication, and determination of the men and women who live there. In 2020, the residents of Pendleton will celebrate the bicentennial of the town—a town recognized for its rich heritage and unparalleled history.

One

PEOPLE

In 1843, Frederick Douglass delivered a speech in Pendleton on abolishing slavery. During his appearance, the 25-year-old Douglass was attacked by an angry mob numbering over 60. Dr. M.G. Walker, Edwin Fossel, and Neal Hardy came to the aid of the severely beaten Douglass, who was taken to Hardy's home, where his wounds were treated. Fifty years later, Douglass reappeared in Madison County, where he spoke of the Pendleton incident and showed no anger or hatred toward his assailants. In his book *The Life and Times of Frederick Douglass*, the abolitionist wrote about his 1843 racist encounter in Pendleton: "As soon as we began to speak, a mob of about sixty of the roughest characters I ever looked upon ordered us . . . to be silent, threatening us . . . with violence."

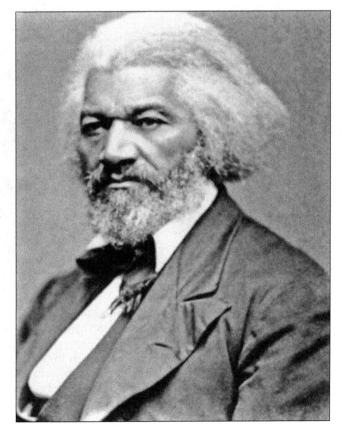

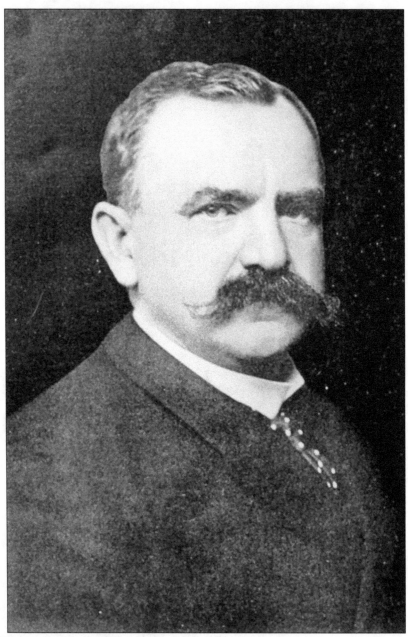

Joseph Swain was born in Pendleton and served as Indiana University's first Indiana-born president. Swain attended Indiana University and graduated in 1883. From 1883 through 1885, he was an instructor of mathematics and biology at the university while completing his graduate education. Swain graduated with a master's degree in 1885 and became associate professor of mathematics until 1886. He left Indiana University in 1891 and became professor of mathematics at Stanford University, then returned to Indiana University in 1893 to serve as the school's ninth president. He met Frances M. Morgan of Knightstown, Indiana, while teaching at Indiana University. The two were married on September 22, 1885. Swain served as president of Swarthmore College from 1902 until his retirement in 1921. He died six years later at the age of 69 and is buried in Friends Cemetery in his hometown of Pendleton.

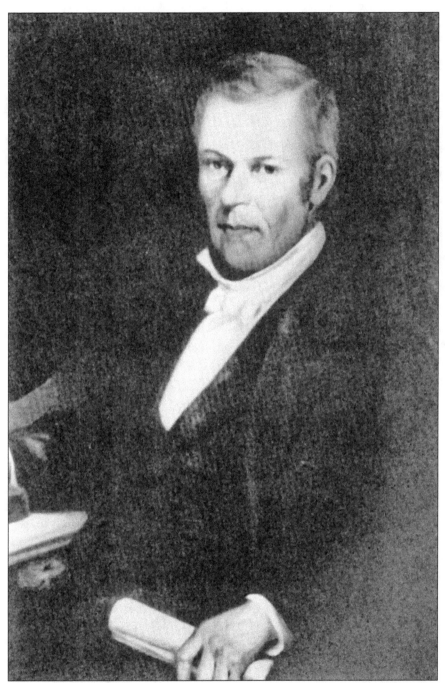

Indiana governor James B. Ray is best known in Pendleton as the man who spared a young man's life. On June 3, 1825, a large crowd congregated at Falls Park to witness the executions of the men found guilty for the murder of nine Indians at the Fall Creek Massacre. After two of the guilty had been hanged, Governor Ray arrived at Falls Park and gave a last minute pardon to 17-year-old John Bridge Jr. after several local residents petitioned the governor to intervene. Governor Ray presented Bridge with a written pardon, then stated, "Here is your pardon. Go sir, and sin no more." Bridge was then set free.

James Noble was the first US senator for the state of Indiana. He served as special prosecutor at the Fall Creek Massacre trial, giving assistance to James Gilmore and Cyrus French, two local attorneys. It was Noble's closing argument that persuaded the jurors to convict James Hudson of murder.

Calvin Fletcher served as one of the two defense attorneys at the Fall Creek Massacre trial. Fletcher was the first attorney to practice law in Indianapolis and was a strong supporter of a free public school system.

Ray Smith, pictured here with his wife, Gertrude, was a third-generation farmer of the Smith family of Pendleton. Smith Family Farms has been in operation for over 100 years and is one of the oldest family-owned farms in Madison County. It has been passed through the family for seven generations and is a working grain and livestock farm. Ray Smith was born on May 23, 1895, to George and Esta Smith. His grandparents were Branson and Emiline Smith. In 2001, Neal and Jennifer Smith were recipients of the Farm Bureau Young Farmer of the Year Award. (Jeanette Isbell.)

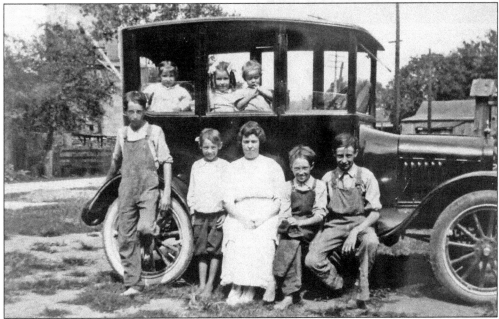

Members of the Owens family pose for a photograph at their Pendleton home. From left to right are (outside the automobile) Orval, Bill, Mother Bessie, Charlie, and Lawrence; (inside the automobile) Alice, Opal, and Geneva. Charlie Owens became a prominent Pendleton businessman, owning and operating Owens Oil Corporation and Owens Ben Franklin Store. As a toddler, Owens lived in Thomas Pendleton's house. He later donated the house to the South Madison Community Foundation to serve as its headquarters.

Homer Motsinger was born in Shoals, Indiana, on March 16, 1875. At the age of 20, Motsinger moved to Pendleton. Upon his arrival, he married Inez Cole, the daughter of a prominent Pendleton businessman. The newlyweds took up residence on North Main Street before purchasing a new home at 204 West State Street in 1900. It was during that year when ground was broken for the Motsinger Device Manufacturing Company, owned and operated by Homer Motsinger. He was living in Chicago when he died on August 13, 1920, at the age of 45.

Homer Motsinger is pictured with his wife, Inez, and son in their 1904 Locomobile Steamer. This family portrait was taken on West State Street in front of the Old Masonic Lodge. (Bob Eley.)

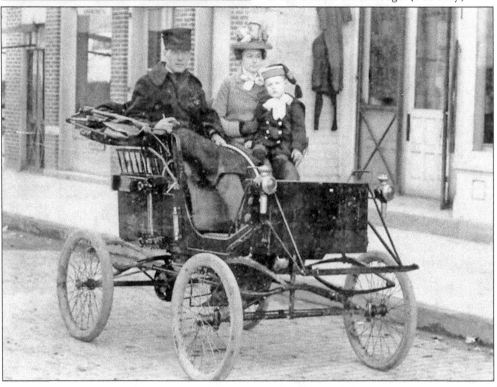

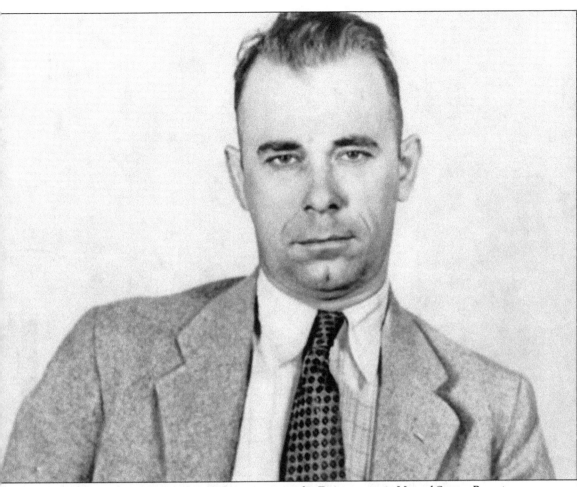

John Dillinger was an infamous American gangster in the Depression-era United States. Born in Indianapolis on June 22, 1903, Dillinger began a life of crime at an early age. During the summer of 1924, while living in Martinsville, Indiana, his ill-fated attempt to rob an elderly grocery store owner led to his quick arrest and conviction. Dillinger was sentenced to 10 to 20 years at Indiana State Reformatory in Pendleton. While there, he worked as a seamster in the shirt factory and played on the prison baseball team. After being denied parole, Dillinger was transferred to the Indiana State Prison in Michigan City. Upon his release from the Indiana State Prison, he and his gang embarked on a crime spree. It was then that the FBI labeled Dillinger as Public Enemy No. 1. Dillinger was gunned down in Chicago on July 22, 1934, and laid to rest at Crown Hill Cemetery in Indianapolis.

The Mother's Circle was founded in the spring of 1918 by Stella Allen and Georgia Hardy. It originated because of a group of children attending the Friends First Day School. Hardy and Allen felt the organization would give mothers the opportunity to discuss the problems of rearing children. In the beginning, only members of the Friends church could belong, but that changed when other mothers from the Pendleton community wished to join. The first mother to join who was not a member of the Friends church was Martha Thomas. Georgia Hardy served as first president of the Mother's Circle, with Greta Hardy as the first secretary. Several photographs and articles appear in the Mother's Circle scrapbook dating back to 1943. Among them is this mid-1950s photograph of the Burke family, including Gerald and Mary Burke and their children Gordon, Karen, Lewis, and Frances. (Pendleton Community Public Library.)

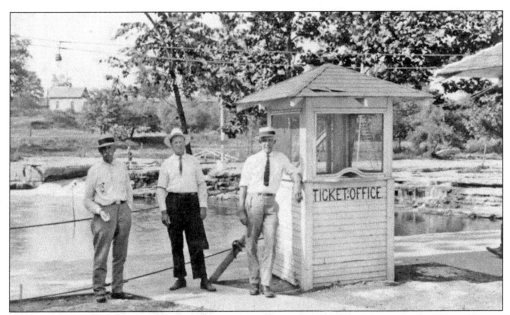

Members of the Pendleton Park Board stand by the Falls Park swimming pool ticket office in the early 1900s. From left to right are D.J. Williams, D.B. Cole, and George Kinnard. Cole was president of the park board.

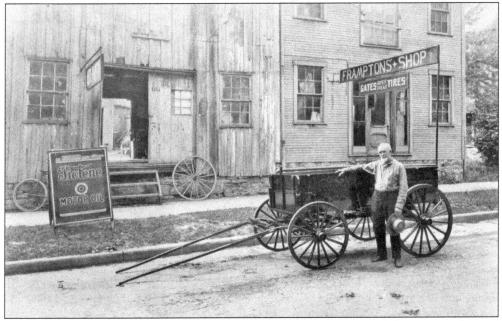

William C. Frampton began building buggies and wagons in 1867. His early business was located at the Darlington Corner. His assistant at the time was Julian Cook. With help from Cook, Frampton built a ladder truck in 1888 that was used by the Pendleton Fire Department until 1922. In addition to building wagons and buggies, Frampton later built auto tops, did machine work, and painted automobiles. He was born in Milton, Indiana, on October 16, 1843, and died on January 21, 1929. Frampton is buried in Pendleton's Grove Lawn Cemetery. Here, Frampton stands outside his shop in the early 1900s.

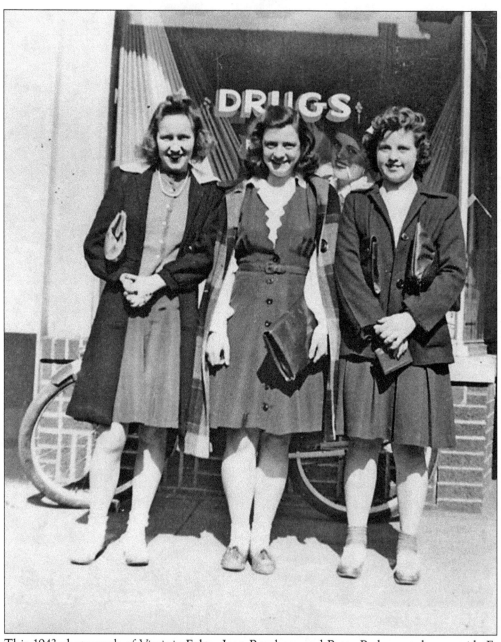

This 1943 photograph of Virginia Eglen, Jean Rambow, and Betty Park was taken outside E. Tanke and Company Druggists at 102 West State Street. E. Tanke sold medicines, paints and oils, newspapers, and magazines. (Jeanette Isbell.)

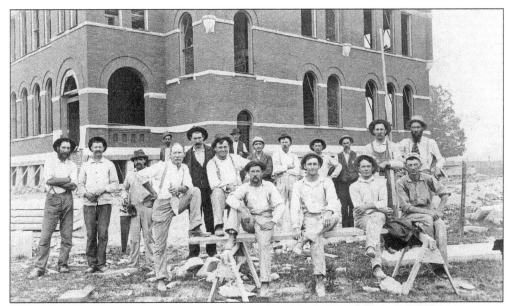

Workers take a break during construction of the original Pendleton High School, which was built in 1895 at a cost of $20,000. The school was located on East Street. (Pendleton Community Public Library.)

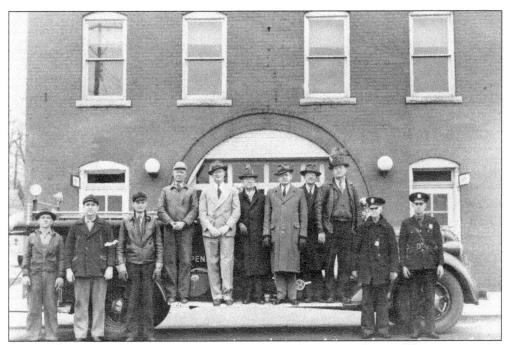

Members of the Pendleton Town Board and town employees pose for a group portrait on the Diamond T fire truck in front of the Pendleton Fire Station and Town Hall. This photograph was taken on March 1, 1943. The building in the background now houses the Pendleton Fire Museum, which displays the same Diamond T truck and other fire department artifacts.

Brother and sister Doug and Mariellen Owens had their portraits taken by Elite Studios in Anderson, Indiana, while attending elementary school in Pendleton. (Both, Fletchyr Owens.)

Wilma Jones and George Kinnard graduated
from Pendleton High School in 1937, along
with 42 other senior students. In the 1937
Papyrus yearbook, Jones had "Redheads
on Parade" listed by her name, while
Kinnard was known as "Mummy's Boy."

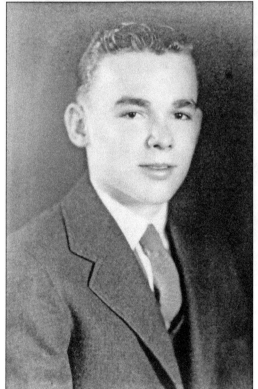

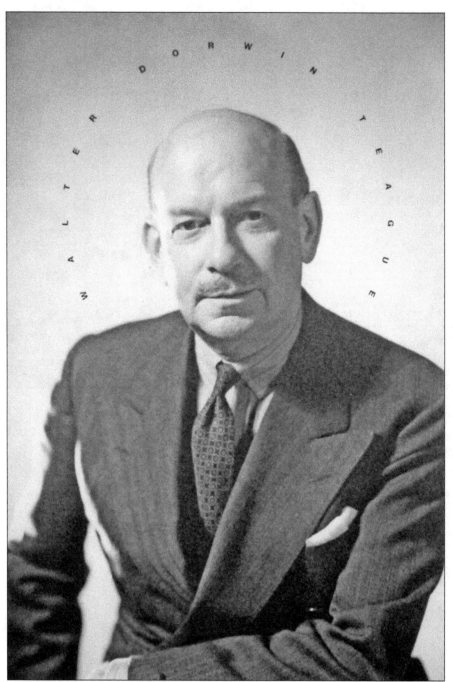

Walter Dorwin Teague was born in Decatur, Indiana, in 1883 and moved to Pendleton at the age of five. He graduated from Pendleton High School in 1902. While a student at Pendleton, Teague read books on architecture in the school library that influenced him to be an artist. At the age of 19, he left Pendleton for New York City, where he studied painting at the Art Students League of New York. Teague has been regarded as a classicist and traditionalist but is also recognized as a key figure in the spread of modernism in America during the mid-20th century. Teague died in Flemington, New Jersey, on December 5, 1960.

In 1945, Teague allowed senior staff members of his growing company to be partners in Walter Dorwin Teague Associates. By the late 1950s, the client list of Walter Dorwin Teague Associates included Polaroid, Procter & Gamble, General Foods Corporation, Steinway, US Steel, DuPont, and more.

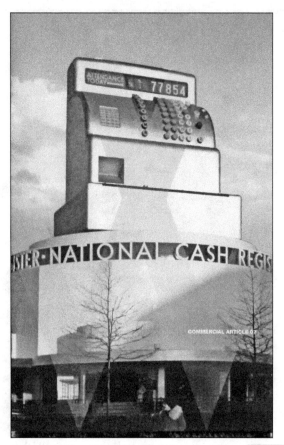

Walter Dorwin Teague is widely known for his exhibition designs from the 1939–1940 New York World's Fair, including a seven-story-tall cash register atop the National Cash Register exhibit that represented his new National Cash Register 100 Model.

Teague designed a number of Kodak cameras, including the 1950 Brownie Hawkeye, one of the most popular cameras ever manufactured.

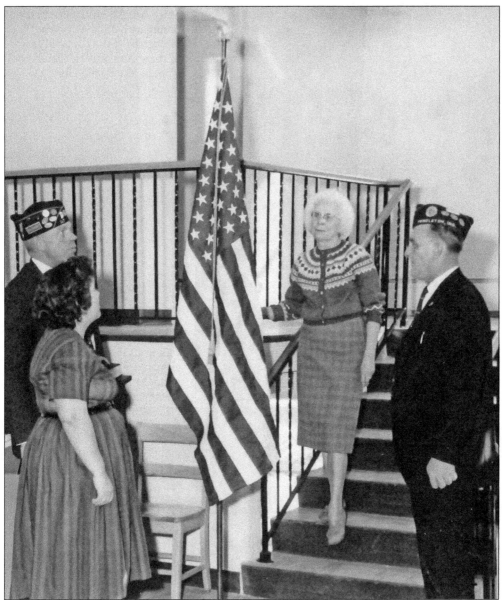

Mary A.J. Ahrens (standing on steps facing flag) served as librarian at the Pendleton and Fall Creek Township Library from September 28, 1953, through September 1, 1972. In 1954, she started the Bookworms program, followed in 1955 with Storyhour. Ahrens loved working with children and made a huge impact on the library and Pendleton community. She was born on April 27, 1894, in Winchester, Indiana, and passed away on August 7, 1985. She is buried alongside her husband, Julius, at Pendleton's Grove Lawn Cemetery. (Pendleton Community Public Library.)

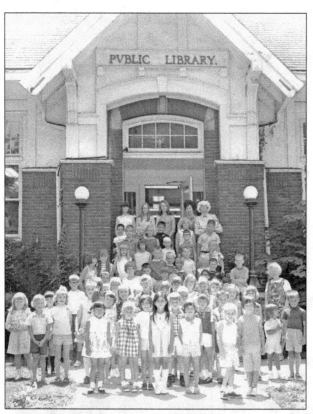

Mary A.J. Ahrens is seen here posing with children on the front steps of the public library in the spring of 1971. (Pendleton Community Public Library.)

Youngsters attend a Storyhour event at the library with Mary A.J. Ahrens. The sign on the wall reads that the event is for elementary school children in grades 1–3. (Pendleton Community Public Library.)

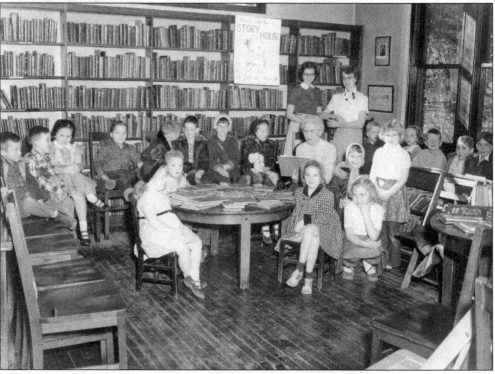

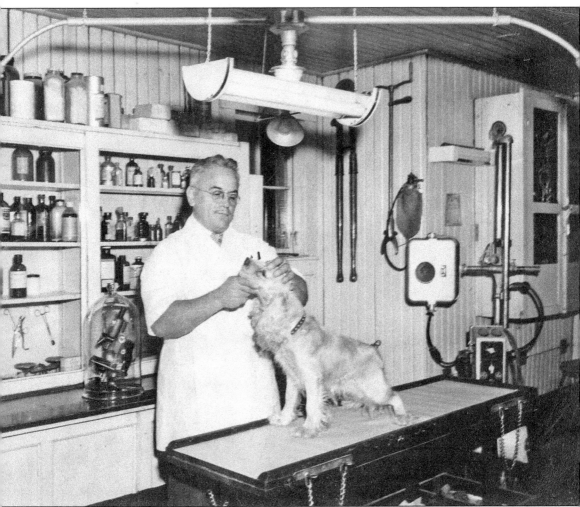

Dr. J.S. Shirley is pictured in his veterinary office at 323 South Broadway in downtown Pendleton. Visible in the background is the first X-ray machine known in the area. Dr. Shirley was a native and lifelong Pendleton resident and veteran of World War I. He was a veterinarian for 42 years before his retirement. In the 1918 Pendleton High School *Papyrus* yearbook, the graduating senior was bestowed the nickname of "Banjo." He served as senior class president and was a notorious statesman and politician in high school. (P.R. Shirley.)

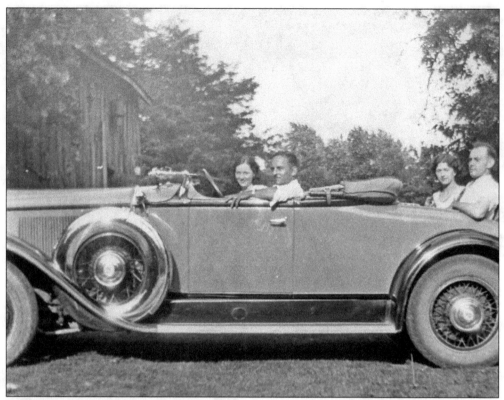

Dr. J.S. Shirley and his wife, Betty, pose for a photograph in his 1929 Buick Roadmaster. The rumble-seat passengers are Mr. and Mrs. Clem Jackson. (P.R. Shirley.)

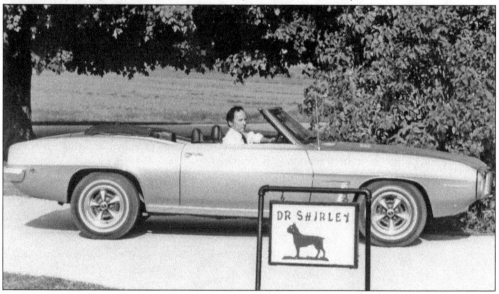

Dr. P.R. Shirley shows that good taste for automobiles runs in the family. He is seen here in his 1969 Pontiac Firebird convertible outside his Pendleton veterinarian office. Now retired, Shirley still lives in Pendleton and is an avid music lover. He played an integral role in the restoration of the historic Paramount Theatre in Anderson. (P.R. Shirley.)

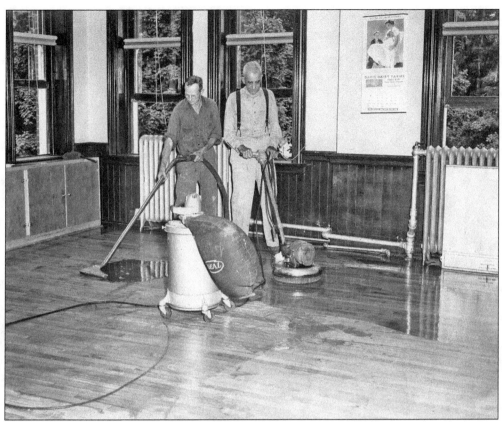

Custodians Earl
Fowler and Bennie
Wisehart clean
and buff floors at
the North School
building. On the wall
is a calendar from
Davis Dairy Farms,
a business once
located in Anderson.
(Kurt Kahl.)

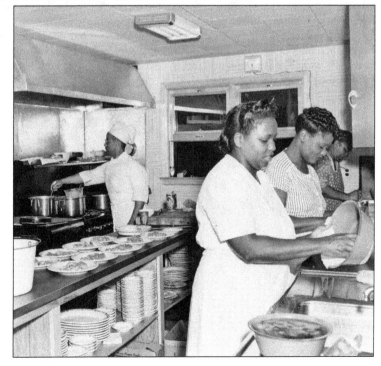

Cooks prepare meals
in the kitchen area at
Idlewold Golf Club
in the mid-1950s. In
2008, the town of
Pendleton purchased
Idlewold and changed
its name to Fall
Creek Golf Club.

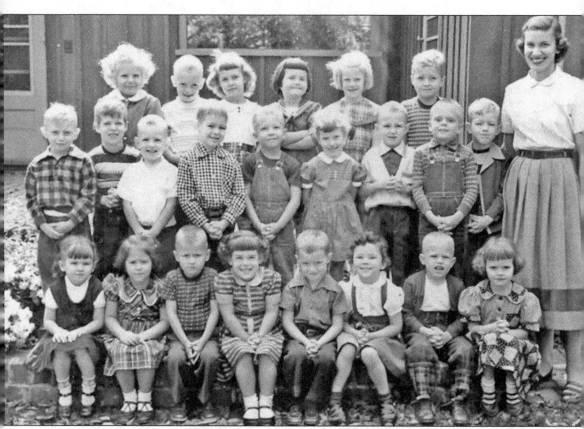

Charlene Daugherty was a private kindergarten teacher in Pendleton for many years. She is seen here with one of her classes from the mid-1950s. Daugherty was not only an educator of the young but also a public servant, historical preservationist, community leader, and volunteer. She was a lifelong member of the Democratic Party and several Madison County organizations. For many years, she was chief gardener and landscaper at Falls Park in Pendleton. Daugherty passed away on August 15, 2012, at the age of 91. (Bob Eley.)

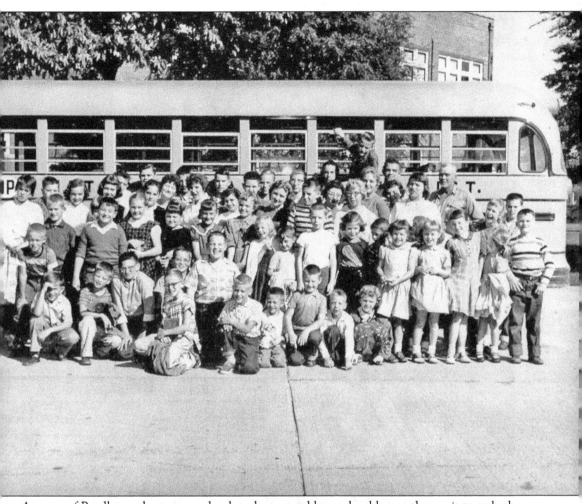

A group of Pendleton elementary school students stand by a school bus as they wait to embark on a field trip in the 1950s. (Leslie Whitmore Gibson.)

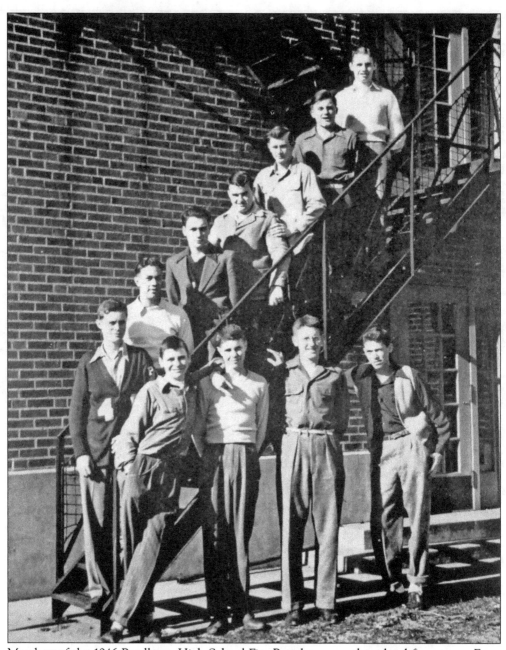

Members of the 1946 Pendleton High School Fire Patrol pose on the school fire escape. From top to bottom are Carl Crull, Richard Somers, John Jarrett, George Mingle, Donald Graham, Herbert Jones, Jim Conner, Fred Emery, Jack Gustin, Tom Harvey, and Kenny Aiman. (Pendleton Heights High School.)

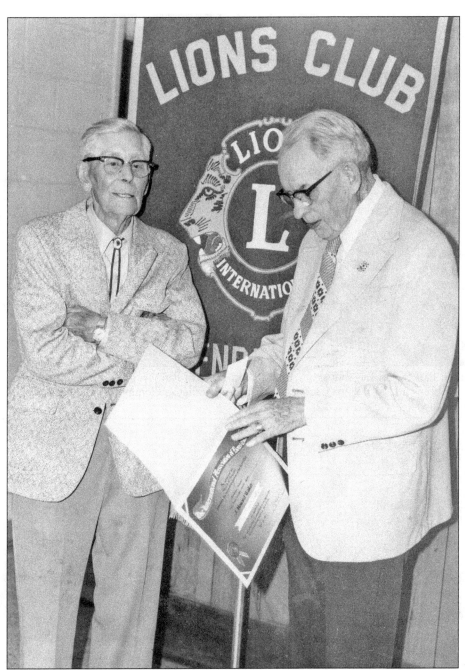

The Pendleton Lions Club was organized on July 17, 1925, with 20 charter members. A Reverend Cady served as the club's first president. Early on, the Lions Club presented an engraved silver trophy to Ruth Dickinson, who had the highest grade average of all Pendleton High School students. Dickinson, a senior, had a grade point average of 93.59 percent. The Lions Club also presented 130 high school students with complimentary tickets to a concert given by the US Marine Band at the Cadle Tabernacle in Indianapolis. Pictured is Bob Martin presenting a life member certificate and plaque to Howard Walker. The date was June 15, 1977. Martin himself was also a life member of the Pendleton Lions Club. (Pendleton Lions Club.)

Donald Parker, Jim Levandoski, Leonard Biby, Howard Rainey, Lloyd Kelley, Jim Kline, and Doug Owens attend a Lions Club meeting at the Pendleton Community Building. (Pendleton Lions Club.)

Willie Thetford, Jim Story, and Doug Owens sit at a table while listening to a guest speaker at a Lions Club meeting. (Pendleton Lions Club.)

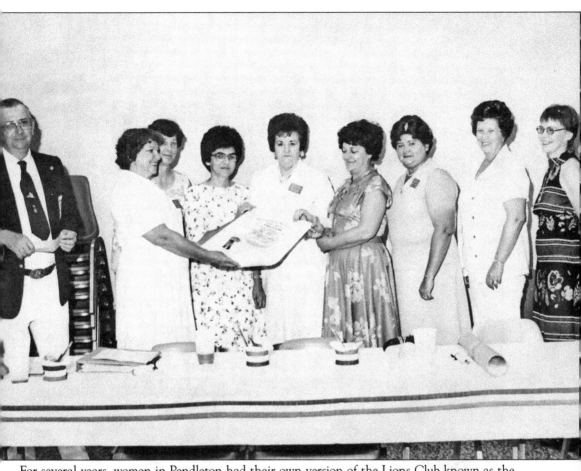

For several years, women in Pendleton had their own version of the Lions Club known as the Lioness Club. Though the Lioness Club disbanded in 1987, women from the community remain actively involved in the Pendleton Lions Club. (Pendleton Lions Club.)

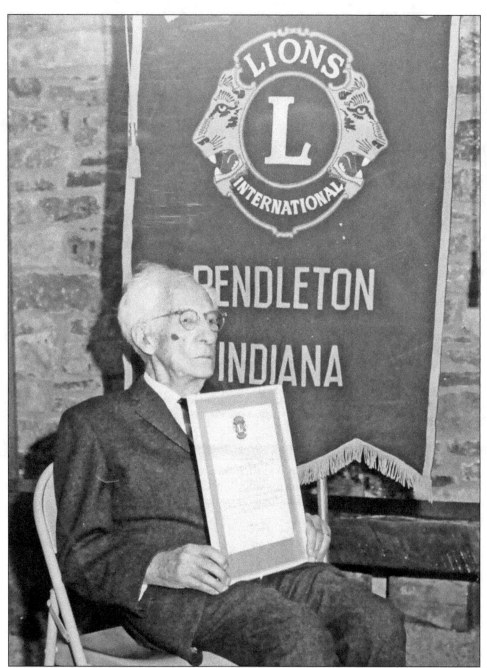

Thomas R. White was born in Kildare, Ireland, on July 27, 1869. He moved with his family to the United States and became chaplain at Indiana University in 1912. During World War I, White served as a civilian chaplain for the Red Cross in Europe. In 1934, he began working as a chaplain at the Indiana State Reformatory in Pendleton. While serving as chaplain at the Reformatory, White felt the need for the prisoners to get an education and founded a school at the prison. The school bears his name, as do diplomas earned by the students. Thomas R. White died in Pendleton on June 19, 1973, at 103 years of age. At the time, he was the town's oldest resident and oldest member of the International Lions Club.

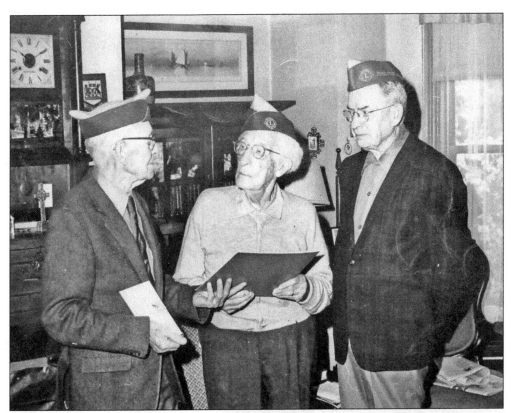

Thomas R. White receives a certificate from Bob Martin and Howard Walker. White became a member of the Lions Club in 1936.

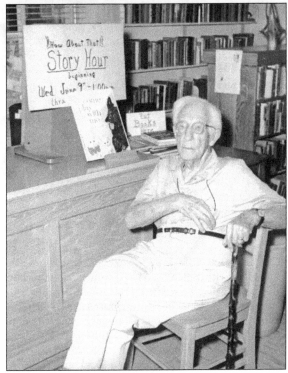

In this 1971 photograph, Thomas R. White is volunteering at the library during Storyhour. (Pendleton Community Public Library.)

Lawrence Keith Bulen graduated from Pendleton High School in 1944, then attended Indiana University, where he studied government, earning a bachelor's degree in 1949. Bulen was elected to the Indiana House of Representatives in 1960 and 1962. He served as campaign chairman for Richard Lugar when Lugar ran for mayor of Indianapolis in 1967 and 1971. Three years later, Bulen helped Lugar get elected to the US Senate. He served as the Indiana coordinator for Richard Nixon's presidential campaign in 1968 and for Ronald Reagan in 1976 and 1980. Bulen was born on December 31, 1926, and passed away on January 4, 1999. (Kassee Bulen.)

Marion County Republican chairman L. Keith Bulen is seen here with Richard Nixon and his wife, Pat, during a February 10, 1968, visit to Washington, Indiana. The former vice president spoke to over 9,000 Republicans at the rally. (Kassee Bulen.)

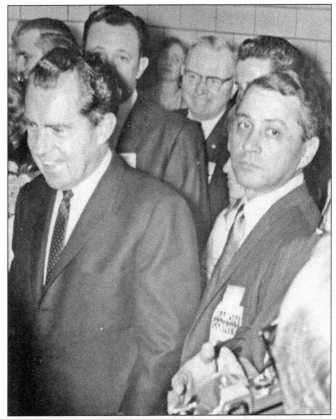

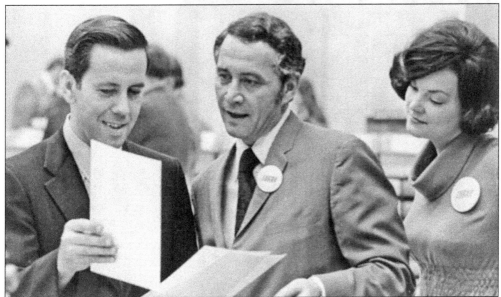

L. Keith Bulen, Carole Bulen, and Richard Lugar review election results in 1971. Lugar was running for a second term as mayor of Indianapolis. The mayoral incumbent defeated Democrat rival John Neff with over 60 percent of the votes. Lugar went on to honorably serve Indiana as a US senator from 1976 to 2012. (Kassee Bulen.)

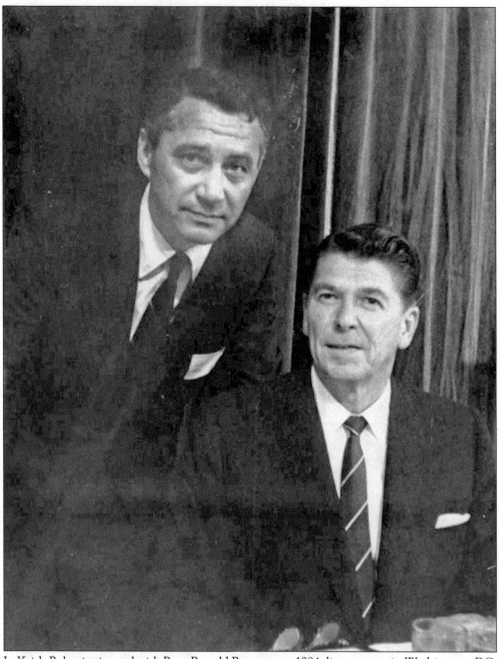

L. Keith Bulen is pictured with Pres. Ronald Reagan at a 1984 dinner party in Washington, DC, during Reagan's first term as president. (Kassee Bulen.)

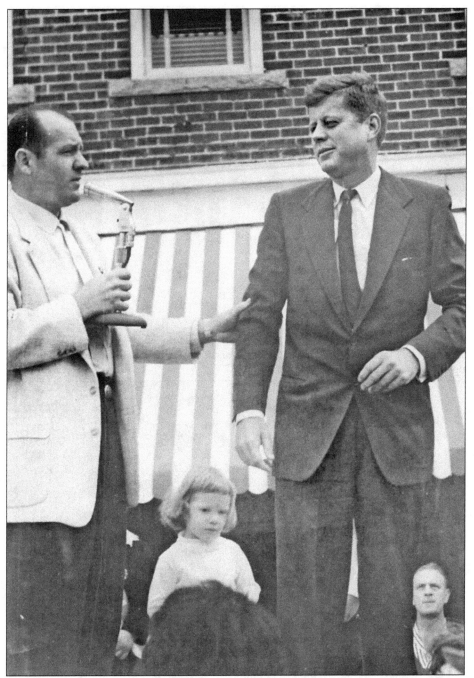

On October 5, 1960, Massachusetts senator John F. Kennedy appeared in Pendleton while campaigning for president of the United States. Dozens of supporters attended the event at the intersection of State Street and Pendleton Avenue. Democrat loyal Jack Mellinger is seen here with Senator Kennedy. At the event, Kennedy told the crowd, "Though I know Indiana has not gone Democratic in any presidential election, I think, since 1936, I believe that the United States and Indiana will move into the Democratic column in November, and I come here today and ask your help." (Madison County Historical Society.)

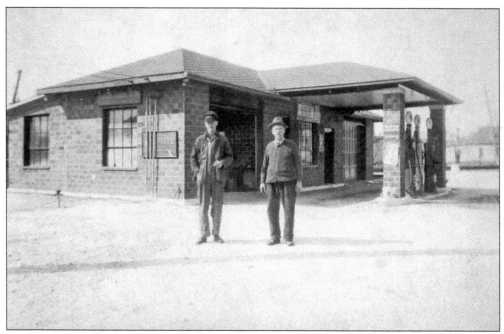

The Royal Service Station was located at 220 South Pendleton Avenue. The business was owned and operated by Lloyd "Cotton" Crosley. Attendants at the service station were Bert Mingle, Sam Propps, Jim Mannon, and a man known as "Hap."

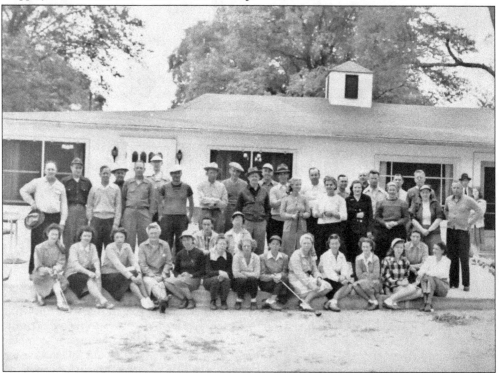

Women and men pose at Idlewold Golf Course sometime during the 1947 golf season. When Idlewold opened in 1920, it was a nine-hole course. Within years, nine more holes were added.

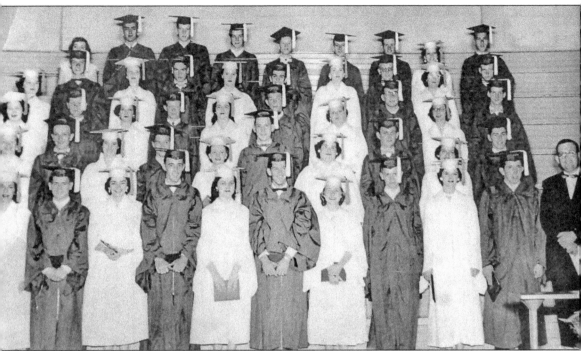

Members of the Pendleton High School graduating class of 1953 are pictured here. In alphabetical order are Donna Adams, Ben Aiken, Ramonia Alexander, Jennie Allison, Fred Ball, Beverly Boyd, Ronald Cassidy, Edwin Chamberlain, Jo Anna Conner, Maurice Crull, Dean Day, Gerald Foust, Larry Gardner, Donald Ginder, Saundra Goff, Laura Graham, Charles Hamilton, Patricia Hamrick, Myrna Harris, Barbara Hopkins, Gene Howard, Patricia Jackson, Russell Jenkins, Evan Keesling, Peggy Keller, Ernie Lawhorn, Ann Lawrence, Richard Lawyer, Phyllis Maul, Steve McCallister, Norman McCurdy, William McVaugh, John Mercer, Marjean Miller, Marvin Myers, Roger Owens, Don Preston, Donald Riley, Betty Schaefer, Lynn Schmitt, Janet Smith, Richard Smith, Halfred Taylor, James Taylor, Donna Kay Tolbert, Margaret Walter, Kathryn Walters, David Weed, and Bonnie Young. (Pendleton Community Public Library.)

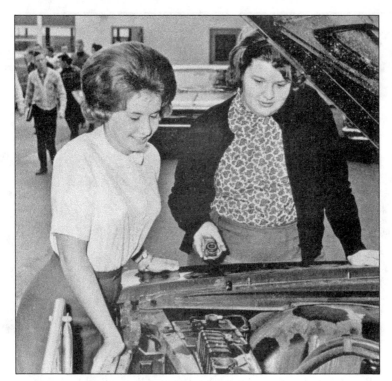

Penny Rumler and Judy Young learn about the engine of an automobile during driver's education class at Pendleton High School. The year was 1965. (Pendleton Community Public Library.)

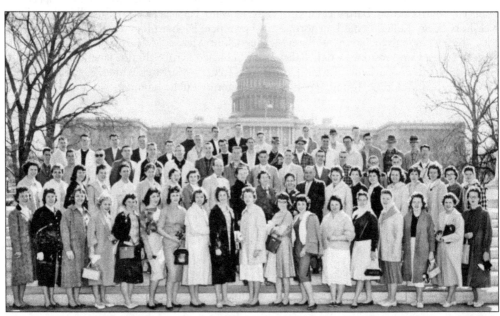

The Pendleton High School senior class of 1960 took a trip to Washington, DC, along with members of the faculty. The travelers boarded the bus on April 4 in Pendleton. Sites seen in the nation's capital included the Lincoln Memorial, Washington Monument, and the Old Christ Church in Alexandria, Virginia. (Pendleton Community Public Library.)

Carma Brown was named Sunshine Girl of the Year for 1967 at Pendleton High School. Nine senior girls received nominations for the title. While at Pendleton High, Brown served as 4-H secretary and was a member of the Spanish club. (Pendleton Community Public Library.)

Fall Festival Queen for 1966 was Pendleton High senior Judy Anderson. The 1967 graduate ranked second in her class and was a member of the National Honor Society and Spanish club. (Pendleton Community Public Library.)

Pendleton High student Billie Lou Tolbert is all smiles after being crowned the 1965 WHBU Miss Teen Queen of Central Indiana. Tolbert was one of 14 finalists from local communities. She was also crowned Miss Christmas Carol 1965 for her prizewinning essay "What Christmas Means To Me." Tolbert's essay was judged the best of all entries by actor Dan Blocker, who portrayed Hoss on the television series *Bonanza*. (Pendleton Community Public Library.)

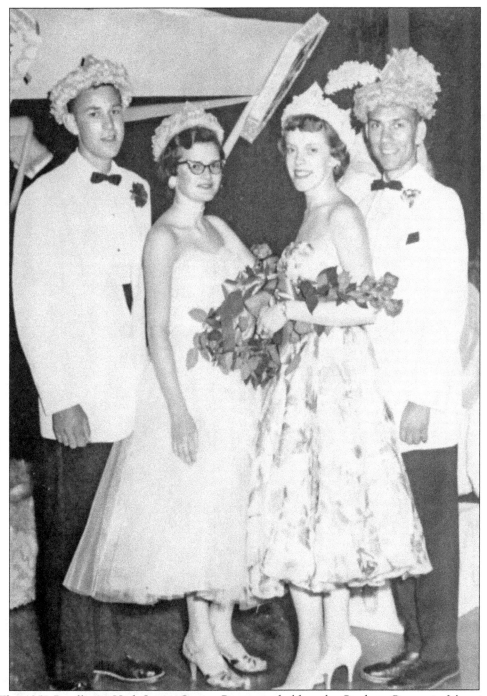

The 1958 Pendleton High Junior-Senior Prom was held at the Student Center in Muncie, Indiana. The theme for the prom was "Pink Carousel" and included decorated pink horses, pink carousels, and pink punch. As with every prom, there was the crowning of the queen and king, and princess and prince. Pictured from left to right are Francis Conner (prince), Judy Baker (princess), Jane Carpenter (queen), and Ed Day (king). The prom was held on Friday, May 23. (Pendleton Community Public Library.)

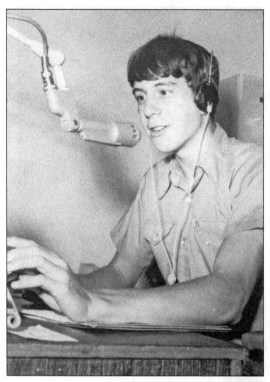

Pendleton Heights High School junior Mike Bare speaks into the studio microphone while broadcasting the news on WEEM Radio in 1972. WEEM FM 91.7 first aired on November 1, 1971. The student-operated station is owned by the South Madison Community School Corporation. (Pendleton Community Public Library.)

Garland Brookbank moved to the Pendleton area in 1916 and was a graduate of Pendleton High School. He served with the Pendleton Volunteer Fire Department for 35 years and was town marshal at the time of the 1936 Pendleton Town Hall explosion.

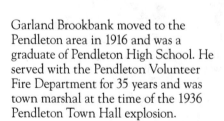

While working at the Indiana State Police Post in Pendleton, Trooper Robert J. Garrison was killed in an auto accident while patrolling State Road 67. Garrison died from head injuries sustained in the accident that occurred on December 14, 1959. He was 27 years old. A second trooper from the Pendleton district, Roy E. Jones, was killed in an auto accident on July 3, 1979. The 31-year-old was responding to a request from the Markleville town marshal when he lost control of his vehicle and slammed into a tree. (Indiana State Police.)

George Daugherty Sr. was one of Indiana's first motorcycle patrolmen at the Indiana State Police Post in Pendleton. Daugherty, pictured here in the late 1930s, was later district commander of the Pendleton post, until he retired in the early 1960s. (Indiana State Police.)

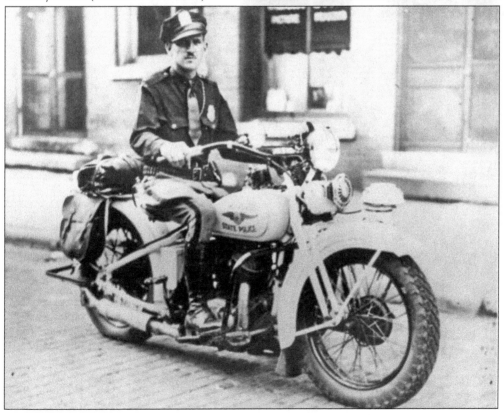

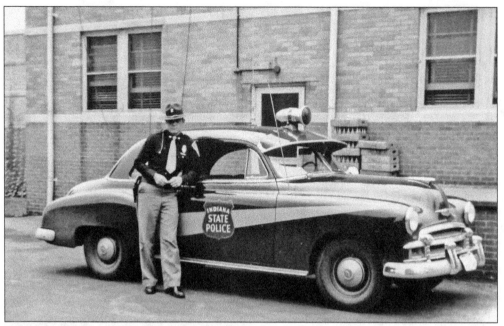

Indiana state trooper Gene Wellman stands beside his 1952 Chevy police car at the Indiana State Police Post in Pendleton. (Indiana State Police.)

Indiana State Police Post commander George Daugherty is seen here with Arthur Godfrey when he visited the Pendleton post in 1957.

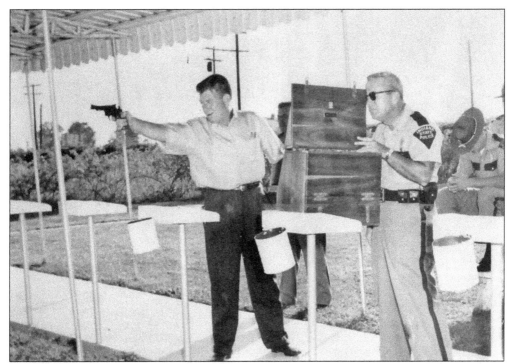

In 1957, radio and television star Arthur Godfrey paid a visit to the Indiana State Police Post in Pendleton. Godfrey, known as "The Old Redhead," is seen here shooting a pistol on the police target range. (Indiana State Police.)

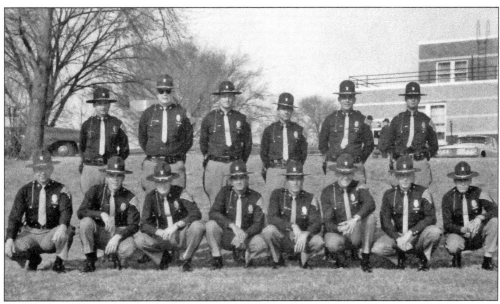

State troopers from the Indiana State Police Post in Pendleton pose for a group photograph in 1966. (Indiana State Police.)

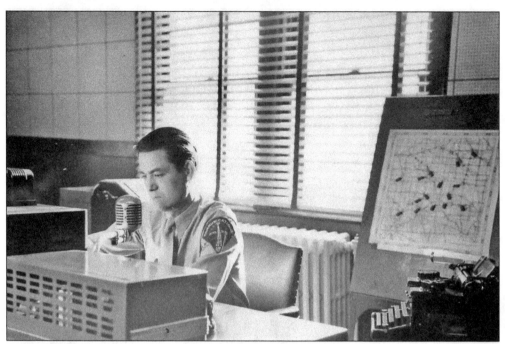

Dispatcher Walter Foutch takes a call at the Indiana State Police Post in Pendleton. His shoulder patch reads "Communications Division." (Indiana State Police.)

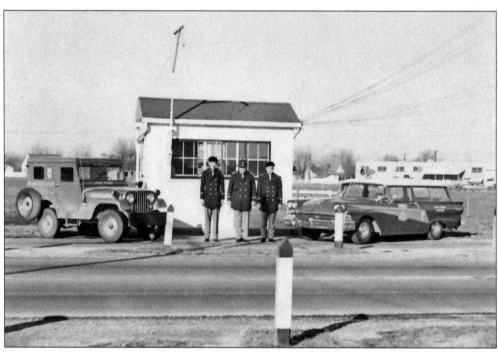

Indiana state troopers from the Pendleton Post stand by a weigh station on State Road 67 sometime in the early 1960s. (Indiana State Police.)

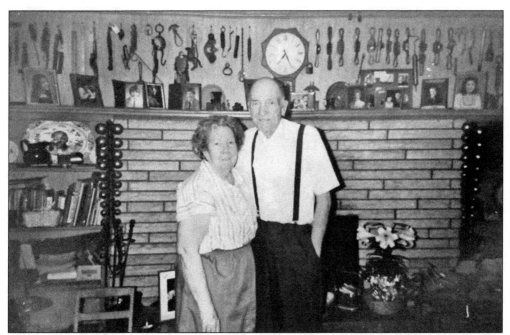

Raymond and Verna Gardner pose in their Pendleton home surrounded by family photographs and antiques. For many years, Raymond owned and operated Gardner Wrecker Service in Pendleton, where people bought and sold auto parts. He and Verna were married for 57 years. (Chris Gardner.)

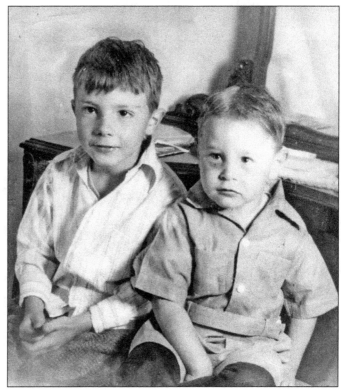

Brothers Fred and Jesse Noble take time out from their rollicking schedule to pose for a picture. Jesse Noble sports a black eye. (Jimmy Noble.)

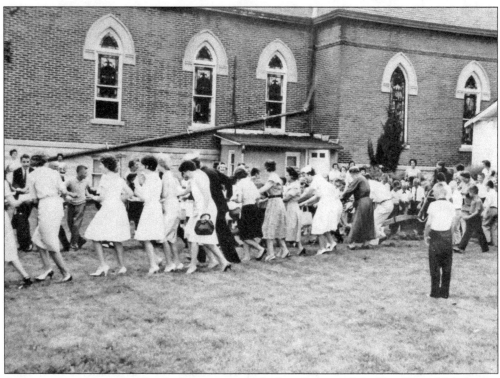

A group of women pull a plow to help remove a shed at the rear of the First United Methodist Church during the late 1960s. (Nancy Wynant.)

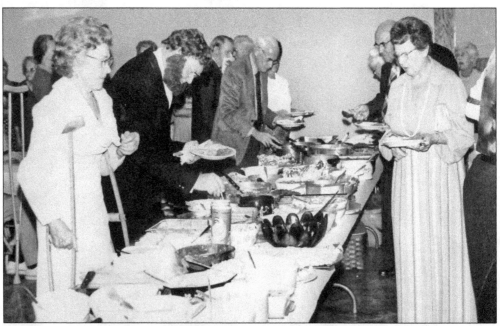

Members of the First United Methodist Church and friends gather for a potluck during the 150th anniversary of the church in 1973. (Nancy Wynant.)

Alfred New dons pioneer clothing to help celebrate the 150th anniversary of the First United Methodist Church. His great-great-grandfather, Martin Chapman, built a log cabin in 1832 that served as an early version of the First United Methodist Church. (Nancy Wynant.)

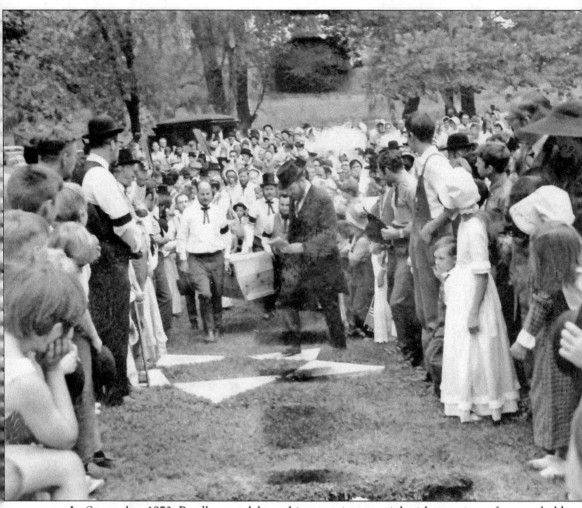

In September 1970, Pendleton celebrated its sesquicentennial with a variety of events held throughout town. One of the events, Fall Creek Heritage, was presented in 12 episodes at Falls Park. The Pendleton Area Sesquicentennial also included a parade, costume contest, and queen contest. In this photograph, the Brothers of the Brush carry the casket of "Wire Edge Willie," a fictitious symbol of the razor blade, to his grave. (Pendleton Community Public Library.)

Jessamyn West was an Indiana-born author best known in the Pendleton area for her book *The Massacre at Fall Creek*. She was guest speaker at the 1981 dedication and opening of the Pendleton Historical Museum. West, a Quaker, was second cousin to Pres. Richard Nixon. After the West family moved from Indiana to California, West attended Sunday school classes taught by Nixon's father, Frank. West later wrote that Frank Nixon's religious and political views inspired her to become a socialist. The acclaimed author died in California in 1984 at the age of 81.

Indiana-born Kurt Vonnegut was the author of several bestselling books, including *Slaughterhouse-Five*. Known for his quirky and candid quotes, Vonnegut once said about Pendleton, "If I had to choose a place and had a choice of places to stay after death, I would choose Pendleton, Indiana, because of its record of fairness to the Indians." (Pamela Bliss.)

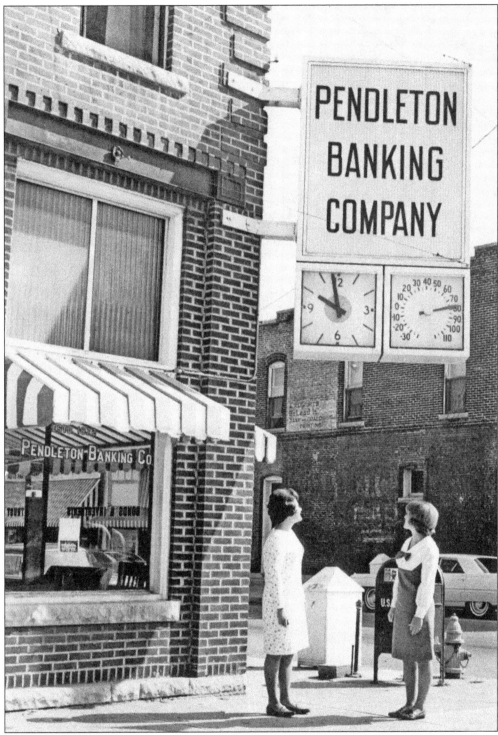

Pendleton High School students Marcia Ginley and Debbie Stoner stand outside the Pendleton Banking Company. This image appeared in the 1966 *Papyrus* yearbook. (Pendleton Community Public Library.)

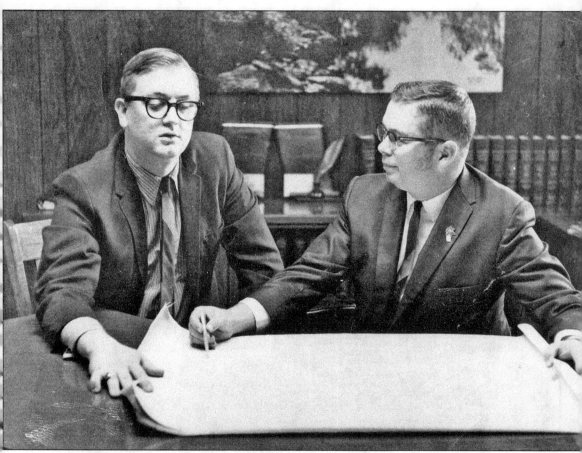

Doug Owens (right) talks with John McLaughlin of Pendleton Savings and Loan about building new homes in the Pendleton area. This photograph was taken in the law office of Doug Owens. (Fletchyr Owens.)

Kiwanis Club president
and charter member Carl
Floyd is pictured with 1963
Pendleton Fall Festival
Queen Beth Morris.
(Pendleton Kiwanis Club.)

Members of the Pendleton
Kiwanis Club get ready for the
1965 Aunt Jemima Pancake
Day. This photograph was taken
at the Pendleton Community
Building. Though pancakes
were the speciality of this
particular day, the Kiwanis
Club is better known for its
famous K Burger sold at various
events in the Pendleton area.
(Pendleton Kiwanis Club.)

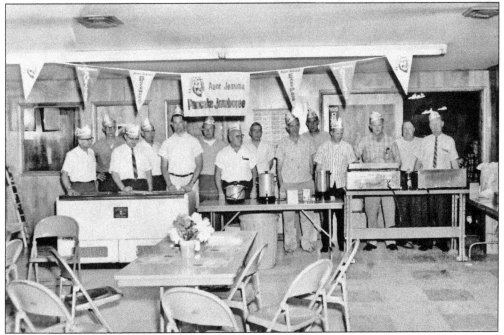

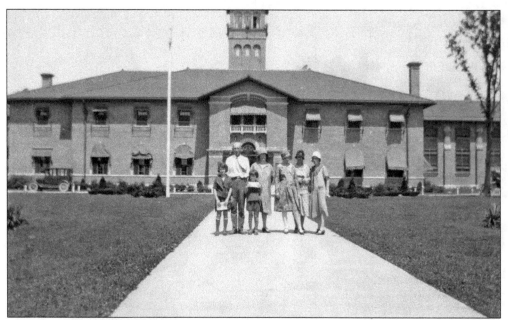

A group of people stand outside the Indiana Reformatory in Pendleton. Information printed on the back of the photograph suggests they may have possibly been visiting an inmate who was a relative or friend.

Students who attended Pendleton High School during the academic year of 1916 met in 1966 for a 50th class reunion.

Vic Cook was creator of The Giant, an environmental house he built and lived in for nearly 30 years. The Giant, located in a wooded area near the Pendleton Reformatory, was powered exclusively with alternative energy and natural materials. Cook used solar panels to generate electricity, which he stored in a battery system provided by Delco Remy; collected water from a cistern; and used a compost toilet. Cook died in April 2010 at the age of 67. A ceremony honoring his life was held at Falls Park the following week on Earth Day. (Anderson *Herald Bulletin*.)

David Murphy is author of *Murder in Their Hearts: The Fall Creek Massacre*, published in 2010 by the Indiana Historical Press. The book is a historian's perspective of the 1824 murder of nine Indians and the trial and execution of the men who carried out the killings. (David Humphrey.)

Irene (Owens) Douglass sits for a photographer in July 1914. Irene modeled fur coats at the White House in Anderson during her early years, and later owned and operated a farm. She founded the Welcome Wagon that took supplies to families who had just moved to Pendleton. (Fletchyr Owens.)

Two

AROUND TOWN

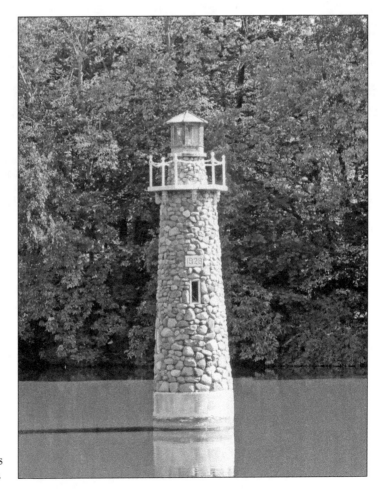

The lighthouse that stands in the center of the duck pond at Falls Park was built in 1928 by Morris Manuel. In the early 2000s, the lighthouse began to tilt and was known as "The Leaning Lighthouse of Pendleton." It has since been repaired and stands as tall and proud as ever.

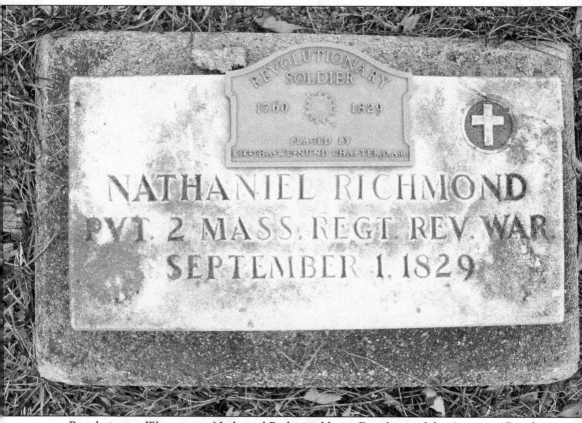

Revolutionary War veteran Nathaniel Richmond has a Daughters of the American Revolution plaque and stone placed in the military section of Pendleton's Grove Lawn Cemetery. Richmond was born in July 1763 in Middleborough, Massachusetts, and was a private of that state's 2nd Regiment. Richmond's discharge was signed by George Washington. He married Susannah Lombard in 1783, and his family moved to Pendleton sometime in the early 1820s. He died on September 1, 1829. Revolutionary War veterans Elijah Boston, Philip Hobaugh, and William Wall are also buried at Grove Lawn Cemetery. (David Humphrey.)

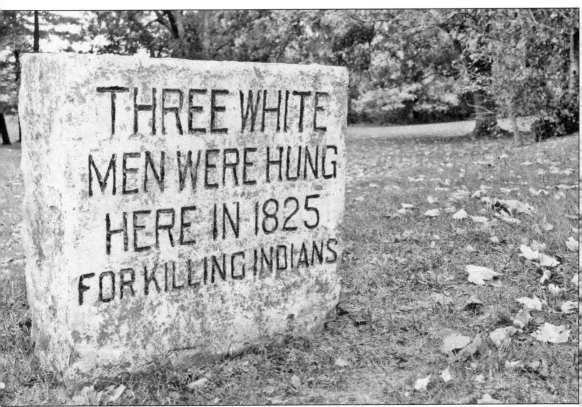

A marker at Falls Park designates the site where James Hudson, Andrew Sawyer, and John Bridge Sr. were hanged in 1825 for the killing of Indians. A large crowd, including several Native Americans, witnessed the executions. (David Humphrey.)

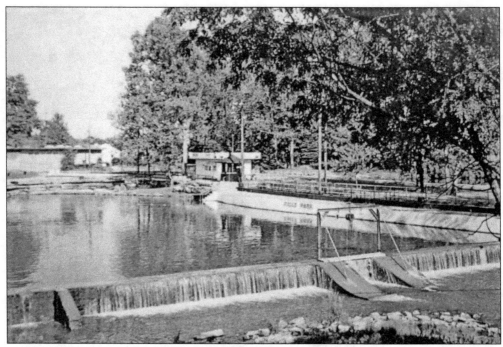

This is a view of the dam built below the falls that creates the swimming pool at Falls Park. In the background is a concession stand and bathhouse. Falls Park opened in 1920.

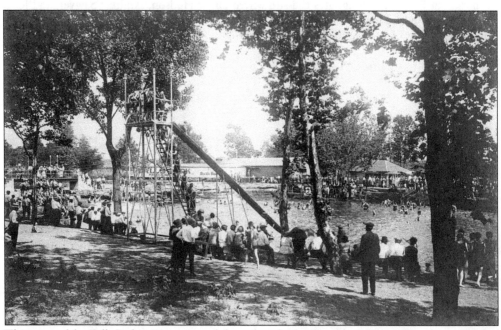

This view of the Falls Park swimming pool shows hundreds of people enjoying the popular facility during the early days. In the background to the left is a group of people standing on the foot bridge that crosses over Fall Creek.

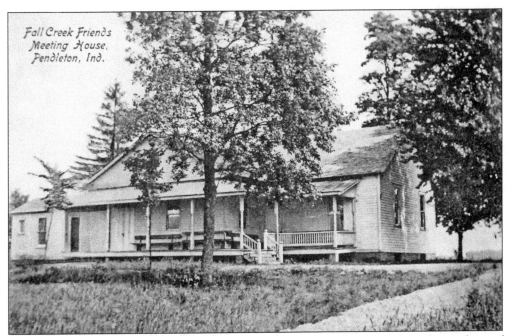

Fall Creek Friends
Meeting House,
Pendleton, Ind.

The Fall Creek Meeting House is a historic Quaker meeting house located on the outskirts of Pendleton on State Road 38 East in Fall Creek Township. The north part of the meeting house was built in 1857, followed by the south section in 1890. The meeting house was an important religious and social center for Quakers, who settled in the Pendleton area during the early years of the town. The meeting house brought Friends together to promote education, equality for women, and to bring an end to slavery. The Fall Creek Meeting House may be one of the oldest Friends meeting houses in eastern Indiana. In 1997, it was listed in the National Register of Historic Places.

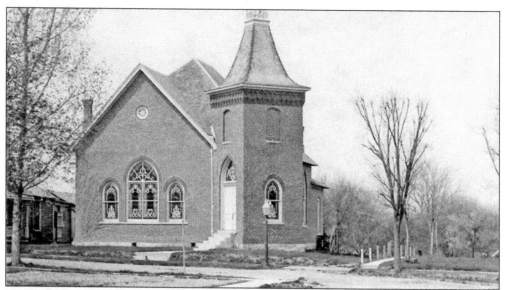

The history of the Universalist Church dates to the winter of 1859. The first organization was known as the Union Universalist Church of Pendleton, whose members held their meetings on the second floor of the Pendleton Academy. Records indicate that a Reverend Gibson was the first pastor and under his leadership, the first church was built. In 1895, the church was razed and a new structure built. That church was torn down in 1938, with the bricks used to build the home of Horace Tunes. Pendleton native Bob Eley resides in that same home today. (Bob Eley.)

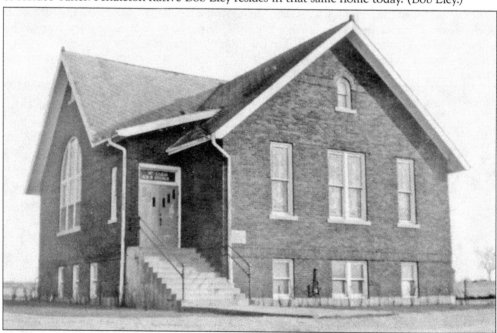

Mt. Gilead Church United Brethren Church was organized in the month of April 1887 by Rev. William Gossett. The trustees purchased a half acre of land from Anthony Reger in Fall Creek Township. The building was remodeled and dedicated on July 4, 1887. A new brick church (pictured) was built at a cost of $13,000 by Rev. A.B. Arford. Dedication took place on May 8, 1921. Today, the facility is known as Mt. Gilead Church.

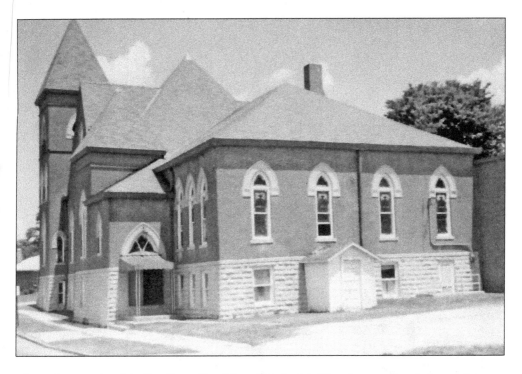

These photographs of the Pendleton First United Methodist Church were taken before and during its March 1967 demolition. The last service held in this facility was February 19, 1967. (Both, Pendleton Community Public Library.)

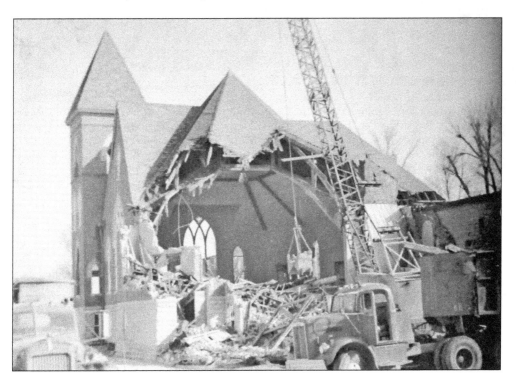

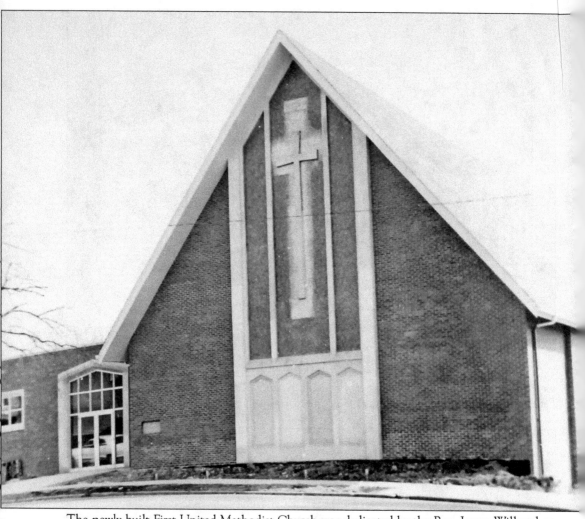

The newly built First United Methodist Church was dedicated by the Rev. James Willyard on February 25, 1968. The Pendleton First United Methodist Church, dating back to 1823, is the oldest church in Madison County. At that time, it was known as the Pendleton Society of the Methodist Episcopal Church. In the early 1900s, the church settled at 225 West State Street, its current site. (Pendleton Community Public Library.)

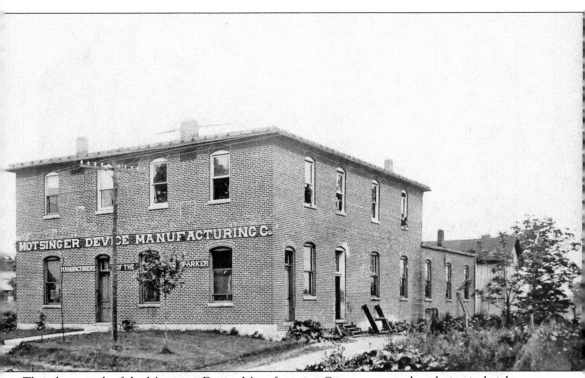

This photograph of the Motsinger Device Manufacturing Company was taken during its height of productivity. The factory, located just north of the falls, allowed inventor Homer Motsinger to manufacture his newly patented Auto Sparker. The factory initially employed 30 skilled tradesmen and 16 laborers working in two shifts. During its stay in Pendleton, the Motsinger Device Manufacturing Company produced an estimated 53,000 Auto Sparkers and 5,000 magnetos, at $20 and $10 each, respectively. The Motsinger Device Manufacturing Company left Pendleton in 1910, relocating to West Lafayette, Indiana. (Bob Eley.)

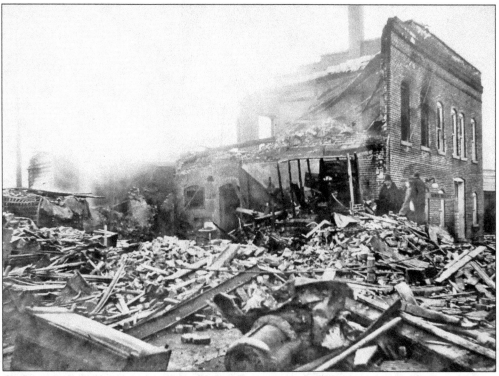

On January 9, 1936, an explosion at the Pendleton Town Hall left five people dead and over a dozen injured. During a town board meeting on the second floor of the building, a 50-year-old toolmaker named Irvin Taylor dropped his glasses through a grate in the floor. Town marshal Garland Brookbank removed a manhole cover on a cistern, allowing Taylor to better retrieve his glasses. Someone at the meeting lit a match, which caused the building to explode. This was the result of sewer gas in the cistern. (Bob Eley.)

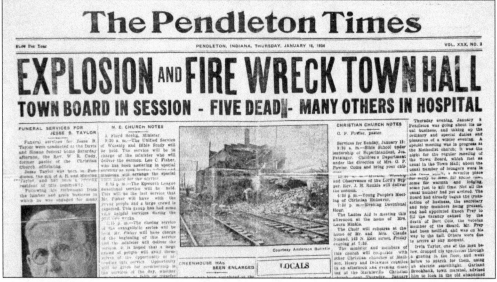

The headline of the January 16, 1936, *Pendleton Times* newspaper pertained to the Pendleton Town Hall explosion. Listed in the article are the names of those killed and injured in the blast.

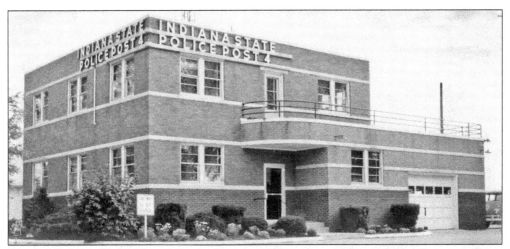

The Indiana State Police Post 4 was built in the 1930s as part of Pres. Franklin Roosevelt's New Deal. The police post was located on the corner of State Roads 9 and 67. In 2011, the building was razed. The new Indiana State Police District 51 opened in the mid-1990s and is located at 9022 South State Road 67.

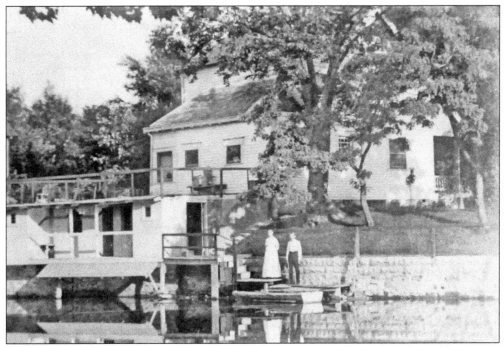

Idlewold Park was owned and operated by Charles McCarty. The park was located one mile south of Pendleton and offered 21 cottages for campers, boats and canoes, horseshoe pitching, and swings and slides for children. Natural springs provided mineral water for drinking, and a concession stand offered refreshments and chicken dinners.

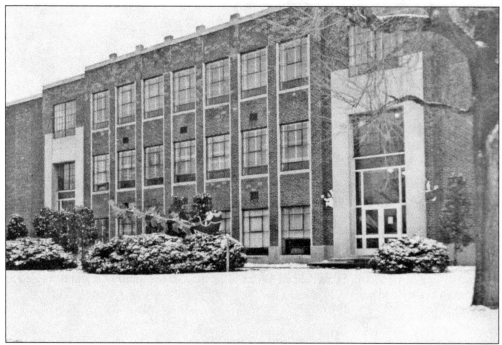

Pendleton High School is pictured in 1962 with the ground blanketed in snow. Pendleton High was built in 1936 and became the Pendleton Middle School in 1969. It was then that the doors of Pendleton Heights High School first opened to students. In 2014, the historic Pendleton High School building became a victim of the wrecking ball, amid outcry from the community.

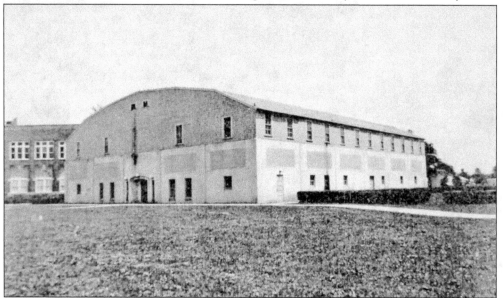

The Pendleton High School gymnasium was located just north of the school and was home to the Fighting Irish basketball team. The gymnasium was dedicated on January 14, 1937, with Pendleton taking on rival Lapel High School. Since there was no heat in the facility, two base burners were placed on opposite ends of the court. Pendleton won the game 24-20. The gymnasium still stands today. (Jay Brown.)

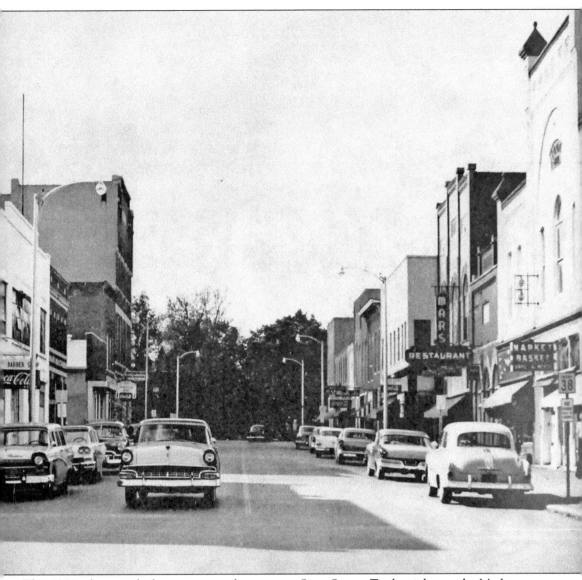

This 1950s photograph shows cars traveling east on State Street. To the right are the Market Basket and Mars Restaurant. There are at least three signs hanging outside businesses advertising Coca-Cola.

The first Indiana State Prison was built in Jeffersonville in 1821. Forty years later, a second state prison was established in Michigan City. The Jeffersonville prison became known as Indiana State Prison South, with the Michigan City facility designated as Indiana State Prison North. In 1897, the Jeffersonville facility was renamed Indiana State Reformatory. In 1918, a fire destroyed a large portion of the reformatory in Jeffersonville, resulting in the Indiana legislature passing a bill to relocate the prison to Pendleton. With construction beginning in 1922, the newly built reformatory opened in 1923.

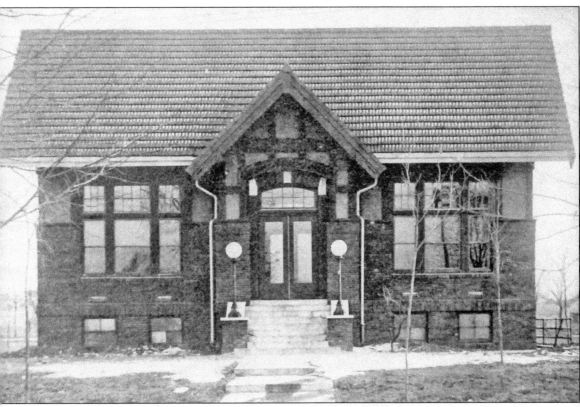

The Pendleton and Fall Creek Township Library was dedicated on March 1, 1912. It was one of 164 Carnegie libraries built in Indiana between 1901 and 1918. The library was made possible through an $8,000 grant awarded by Andrew Carnegie. Located at 424 East Street, the library was dedicated on March 1, 1912, and served as the Pendleton library until 1991. It is now the site of an alternative school known as the Carnegie Learning Center.

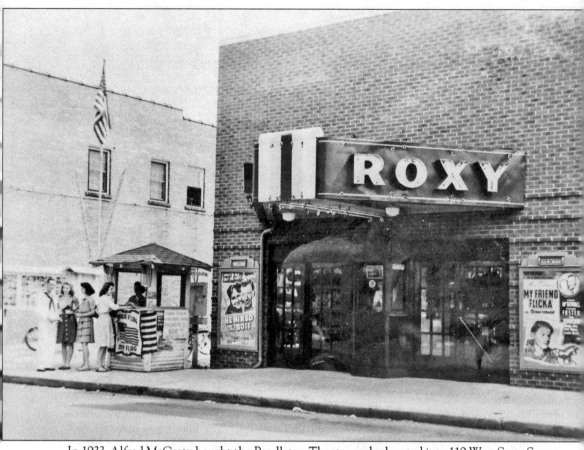

In 1933, Alfred McCarty bought the Pendleton Theatre and relocated it to 119 West State Street. The name of the venue was changed to the Roxy Theatre. In this photograph, *My Friend Flicka* and *He Hired the Boss* were showing as a double feature. Both films were released in 1943.

In 1981, the Pendleton Historical Museum Board was established and the old bathhouse was converted into a museum. The Pendleton Historical Museum is operated by a dedicated group of volunteers and is open on weekends from May through October. Hundreds of artifacts can be viewed on the first and second floor of the museum, with displays rotated on a regular basis. Though Pendleton is the main subject of the museum, items from the nearby towns of Ingalls and Markleville are also on display. (Both, David Humphrey.)

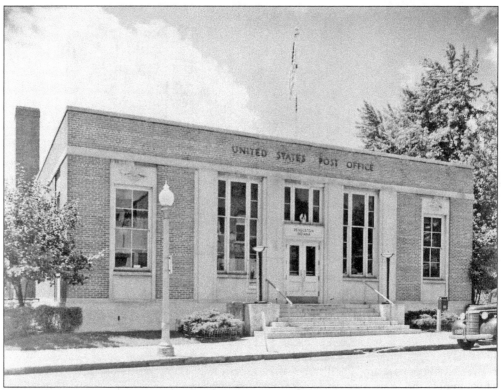

The Pendleton Post Office was a construction project of Pres. Franklin Roosevelt's New Deal. Construction began in July 1936 and was completed in April 1937. The estimated cost was $65,000. In 1966, $185,886 was spent on remodeling the post office. Local mail delivery in Pendleton began in 1926, with Kenneth Lukens serving as the first letter carrier. This photograph shows the Pendleton Post Office as it looked in the 1950s.

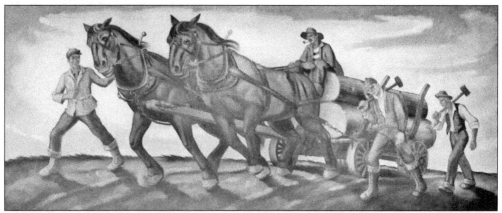

This mural, titled *Loggers*, is on display in the Pendleton Post Office at 137 East State Street. The oil-on-canvas mural was created by artist William Frederick Kaesar and was funded by the Section of Fine Arts of the US Treasury Department. The artist received $560 for painting the mural. Post offices constructed in the 1930s during President Roosevelt's New Deal were decorated with murals depicting life in America. From 1935 through 1942, murals were created for 42 Indiana post offices.

Three

THOSE WHO SERVED

Raymond Bower was in the US Army and served in World War I. Bower was born in 1895 and registered for the draft on June 5, 1917. The World War I veteran also registered to serve his country in World War II. He died at the age of 48 at his Pendleton home.

Jack A. Hite worked for the US Army Security Agency in South Korea between 1957 and 1960. The security agency that Hite was involved with was the first to pick up the signal from the Soviet Sputnik satellite. (Peggy Clark.)

Glenn I. Hite was a sergeant in the US Army during World War II. He was involved in the third landing on Normandy Beach and was referred to as "Pop" because of his age. (Peggy Clark.)

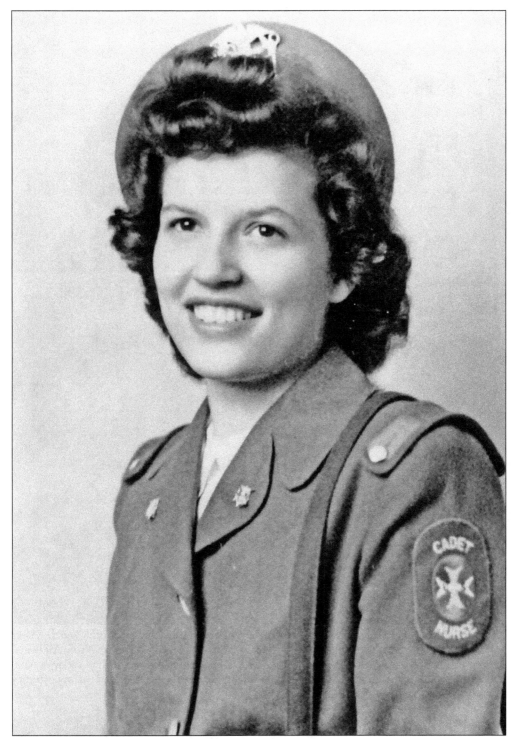

During World War II, Dorothy (Dillenback) Jarrett served in the US Nurse Cadet Corps from 1944 to 1947. She was a graduate of St. John's Hospital nursing program in Anderson. Her husband, Jack Jarrett, also served in World War II in the US Navy.

Estelle Belle (Blakely) Fuller felt there was a need to serve others during World War II. After graduating from the nursing program at St. John's Hospital, she enlisted in the US Army Air Force. Fuller was stationed at a depot in Albuquerque, New Mexico, before transferring to Santa Ana, California. She was chief nurse at both bases. While in New Mexico, Fuller had the opportunity to meet war correspondent Ernie Pyle.

Jim Craig fought on Iwo Jima in World War II and is the subject of the book *The Last Lieutenant: A Foxhole View of the Epic Battle for Iwo Jima* by John C. Shively. (Annie Wills.)

Walter Bert Smelser served as a technician during World War II and was a recipient of the Bronze Star for combat bravery. Smelser was born on July 12, 1919, and passed away on October 11, 2002. He was a member of Pendleton Amvets and American Legion Post No. 117. (Smelser family.)

Jesse Noble served in the US Navy during World War II aboard the USS *Pandemus*. Following the war, he received a letter from Pres. Harry S. Truman. A portion of the letter read, "As one of the Nation's finest, you undertook the most severe task one can be called upon to perform." (Jimmy Noble.)

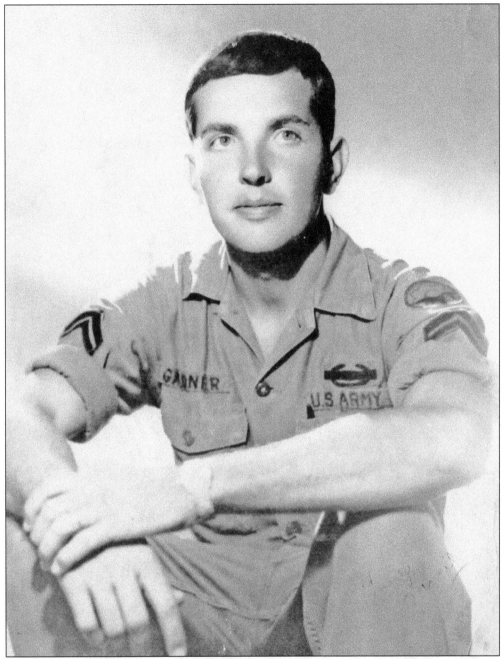

Lannie Gardner served one tour of duty in the Vietnam War in 1968–1969. He fought in the 9th Infantry of the US Army. (Chris Gardner.)

US Navy seaman Thomas Gilbert Owens was killed in action on December 11, 1944. He had just turned 18 the previous August. (South Madison Community Foundation.)

George L. Kinnard was a first lieutenant in the US Army in World War II. He received the Purple Heart and wrote about his wartime experiences in an essay titled "My Trip in the North Atlantic."

Richard E. Christian enlisted in the US Navy in 1952 during the Korean War. He served four years as an electrician's mate second class and was discharged in January 1956. (Theresa Christian Stapleton.)

Four

PROGRAMS, DOCUMENTS, AND ADVERTISEMENTS

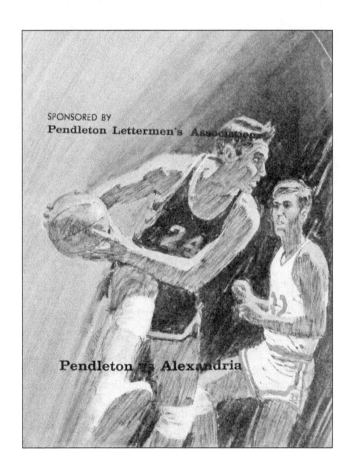

This is the program for the final home basketball game for Pendleton High School. Pendleton played Alexandria High School and defeated the Tigers by a score of 67-61.

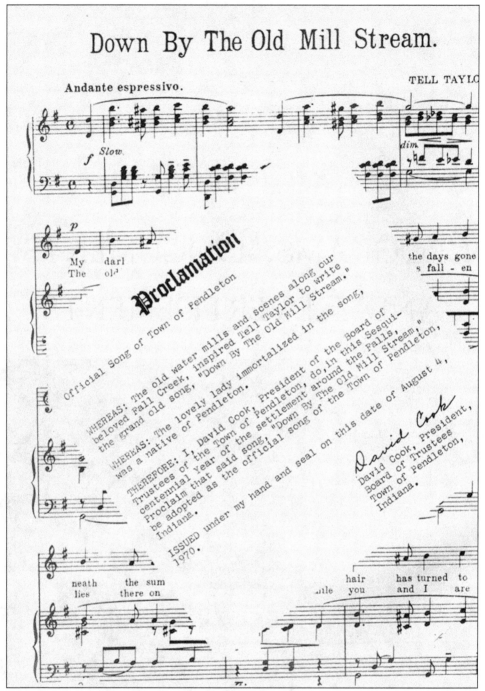

During the sesquicentennial year of Pendleton, "Down by the Old Mill Stream" was named the official song of Pendleton. The proclamation, dated August 4, 1970, was signed by David Cook, president of the Town of Pendleton's Board of Trustees. "Down by the Old Mill Stream" was written in 1910 by Tell Taylor, who drew inspiration for the song from the old water mills and scenery along Fall Creek. Forster Music Publishing of Chicago sold four million copies of the song.

The Belfast Lions Club

congratulates

Lion Dr. Thomas Robert White, D.D.

on the occasion of his

One Hundredth Birthday

on Sunday 27th July, 1969,

and on the occasion of his visit to our regular club meeting on Monday 28th July 1969, we are proud to install him as an Honorary Member of this Club.

President, Belfast Lions Club

On July 27, 1969, Thomas R. White celebrated his 100th birthday. The Belfast Lions Club installed White as an honorary member. After White was forced to retire from his position at the Pendleton Reformatory, he said, "My work at the reformatory tops off everything I ever did. I know the rough side of things and learned to meet the prisoners on the same level. The job wasn't to preach and pray to them; it was much more."

INDIANA REFORMATORY
PENDLETON

BERTILLON MEASUREMENTS

76 .1	81.	93.	18.5	15.7	14.4	6.1	26.	11.6	9.	47.3

F. P. Classification— (26) 31 IMI 0
32 OII 14

CIRCULAR FILE No.

$25
REWARD
FOR ARREST AND
DETENTION

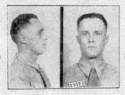

$25
REWARD
FOR ARREST AND
DETENTION

25122 **GUST WOZNIAK** 25122
R. N. KOSTEK WOZNIAK

Height; 5 ft. 9 1-2 inches. Complexion, Fair. Eyes, Brown. Hair, Brown. Weight, 148.
Build, Medium. Occupation, Crane Operator. Nationality, American. Born at Lorain, Ohio,
5-25-08.
MARKS & SCARS: II. Sc. 1"x1-8" on back of hand.
CORRESPONDS WITH: Brother Mike Wozniak, 3851 Casmere St., Detroit, Mich.
RECEIVED: 4-24-35.
CRIME: Second Degree Burglary. TERM: 3-10 years.
ESCAPED: 3-7-37.

PLEASE FILE WITH FINGERPRINTS OR BERTILLON RECORDS

A reward of $25 was offered for the arrest and detention of Gust Wozniak, who escaped from the Indiana Reformatory in Pendleton on March 7, 1937. Wozniak was arrested for second-degree burglary and sentenced to serve 3 to 10 years at the reformatory.

INDIANA REFORMATORY
PENDLETON

BERTILLON MEASUREMENTS CIRCULAR FILE No. 689

76.6	77.	94.	19.6	16.1	14.3	6.5	25.8	11.5	9.5	46.

F. P. Classification— 1 R 00 16
1 U 00

$25
REWARD
FOR ARREST AND
DETENTION

$25
REWARD
FOR ARREST AND
DETENTION

25368 **WILLIAM GOODWIN** 25368

Height, 5' 9 1-2". Weight, 156 lbs. Complexion, Fair. Eyes, Blue-Brown. Hair, Dk. Cht.
Build, Medium. Occupation, Soldier. Nationality, American. Born at Detroit, Mich., Aug. 6th,
1915.
MARKS & SCARS: I. Tattoos: Heart with initials J. C. in center on upper arm outer.
Initials W. G. on forearm outer. III Ridge of nose broken to right.
CORRESPONDS WITH: Wife, Martha Goodwin; Mother, Ruth Goodwin, and
brother, Leonard Goodwin, all at 1452 Hyatt St., Indianapolis, Ind.
RECEIVED: 8-24-35 from Indianapolis, Indiana.
CRIME: 2nd Degree Burglary. TERM: 1 to 10 years.
ESCAPED: 4-21-36.

PLEASE FILE WITH FINGERPRINTS OR BERTILLON RECORDS

William Goodwin escaped from Pendleton's Indiana Reformatory on April 21, 1936. He was serving 1 to 10 years for second-degree burglary. A $25 reward was offered for his arrest and detention.

Chautauqua was an adult education movement in the United States, vastly popular in the late 1800s and early 1900s. The Chautauqua provided entertainment and culture for the community with speakers, musicians, singers, preachers, and specialists of the day. In 1917, Dr. L.E. Follansbee, the Hon. Chester H. Aldrich, and the Mendelssohn Sextette were on the bill when Chautauqua was in Pendleton.

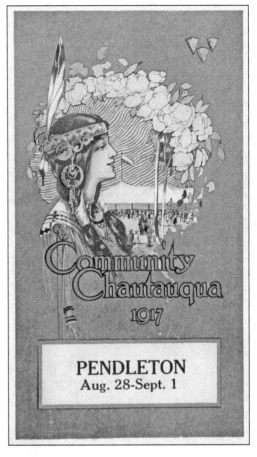

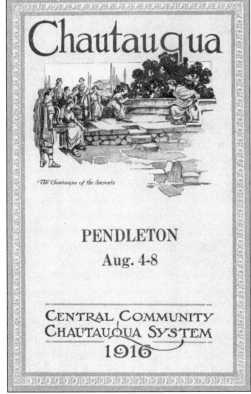

During the summer of 1916, the Chautauqua made a stop in Pendleton. Admission for adults ranged from 25¢ to 50¢, with children's tickets costing 15¢ to 25¢. Artist J. Franklin Caveny, the New York City Marine Band, the Collegian Trio, and the Handel Choir were listed in the program. (Debbie Jo Young Depuy.)

97

This diploma was presented to Pendleton High School graduate Horace E. Mingle on May 27, 1924. Signatures on the diploma included Pendleton High principal Floyd Miner, school superintendent Irvin Ellsworth, and members of the Pendleton Board of Education.

This program was for attendees of the Pendleton Public Schools Commencement that took place May 29, 1913, at the First Christian Church. The phrase *Esto quod esse videris* translates to "Be what you seem to be."

COMMENCEMENT

First Christian Church

Thursday Evening, May 29, 1913.

The second-annual Pendleton Community Fair took place October 13–15, 1921. President of the event was A.T. Manuel. Prizes were awarded for best apples, best grapes, best pears, woodworking, leather, furniture, and blacksmithing.

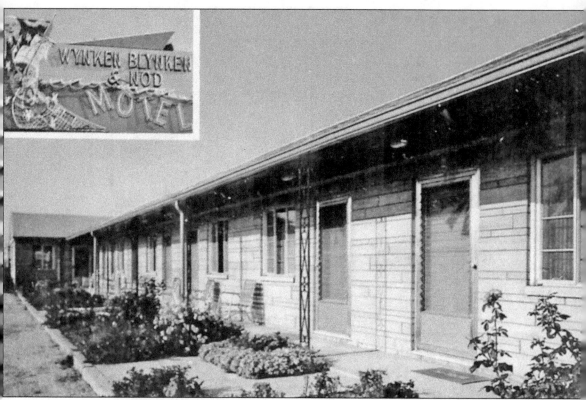

This is a postcard for the Wynken, Blynken, and Nod Motel, once located near the intersection of State Roads 67 and 38. The motel was owned by James and Leddie Litchfield and offered sleepy travelers 10 air-conditioned rooms, private tiled showers, and Beautyrest mattresses. The Wynken, Blynken, and Nod Motel later became the Pendleton Motel. (Bob Eley.)

Five

ENTERTAINMENT

William Walker was born in
Pendleton on July 1, 1896, and
is a graduate of Pendleton High
School. He began his acting
career in the mid-1940s. Over
five decades, he appeared in
numerous television shows and
movies. Walker died in 1992 and
is buried at Riverside National
Cemetery in Riverside, California.

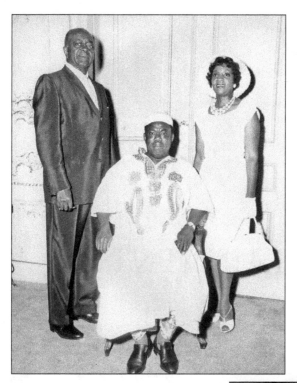

William Walker and fellow actor Paulene Myers are pictured with Julius Momo Udochi, who served as the first Nigerian ambassador to the United States from 1960 to 1965. In 1974, Walker and Myers appeared together in the film *Lost in the Stars*.

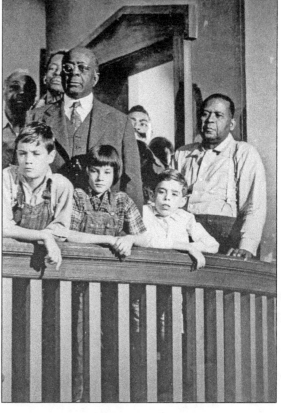

Though William Walker appeared in dozens of movies and television programs, he may best be remembered for his role as Reverend Sykes in *To Kill a Mockingbird*. The movie was based on Harper Lee's 1960 Pulitzer Prize winning novel of the same name.

William Walker is pictured with James Garner on the set of the television program *Yancy Derringer*, a Western series that ran on CBS from 1958 to 1959.

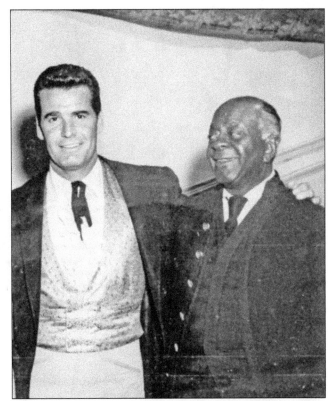

In 1954, William Walker appeared in the film *The Outcast*. He is pictured here with actor John Derek in a scene from the movie.

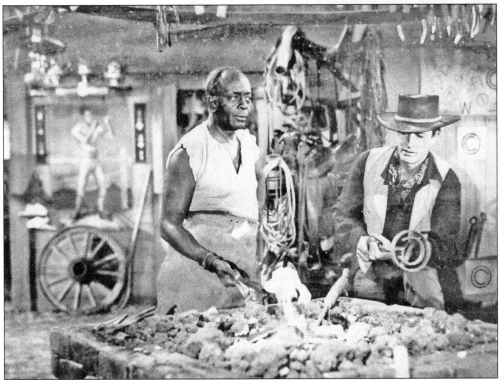

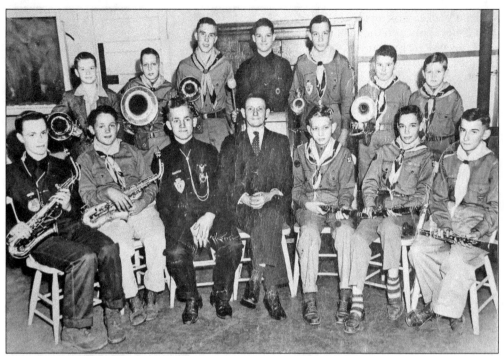

Members of the Pendleton Boy Scout Troop 232 band are gathered for a group picture in 1950. From left to right are (first row) Kenneth Mercer, Denny Smith, Bob Deadman, Bob Jones (scoutmaster), Meredith Chamberlain, Dave Mercer, and Presley Peek; (second row) Donald Neece, Paul Ayers, Bill Hayden, Dave Waggoner, Max Mercer, Joe Shelton, and Herb Ayers.

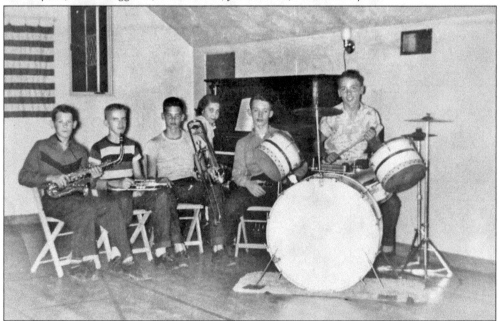

During the 1950s, the Boogie Bugs were a group of young musicians who performed in the Pendleton area. From left to right are Dale Foutch, John Maker, Jay Whitworth, Jo Ellen Hollowell, John Roop, and Phillip Shirley. (P.R Shirley.)

From the 1940s through the 1960s, Verna Whitworth performed to over 10,000 schoolchildren in the central Indiana area. Whitworth visited up to 52 elementary schools each year with "The Best Things in Life are Free" as her theme song. For 36 years, she hosted a radio program called "A Visit With Verna." In later years, she broadcast from her home, playing the piano and singing songs, with listeners singing along with her. Verna Whitworth loved working with children. She officially retired as an entertainer in 1983 and passed away in 2001.

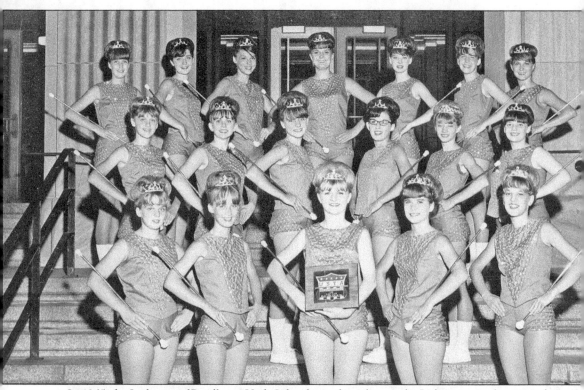

In 1965, the Irishettes of Pendleton High School won first place at the Indiana state championship baton twirling contest. Members of the baton twirling squad are Dianah Hazel, Jennifer Moore, Mary Philbert, Linda Burke, Gloria Sniegowski, Deidra Palmer, Jeanne Lawyer, Carol Fulk, Patty Fabian, Beverly Widener, Brenda Hayden, Karen Hammond, Susan Cover, Diane Ford, Tonya Smith, Cindy Abney, Susan Valentine, and Billie Tolbert. (Linda Castor.)

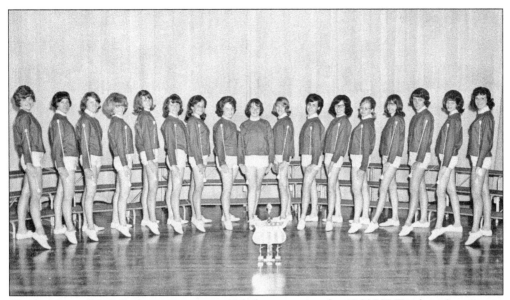

The Pendleton High Irishettes were crowned champions at the 1966 US Twirling Association (USTA) Grand Nationals in Grand Rapids, Michigan. The Irishettes are Patty Fabian, Mary Philbert, Cathy Smith, Tonya Smith, Jennifer Moore, Neeca Bannon, Diane Ford, Marta Michael, Kathy Sparks, Dianah Hazel, Deborah Crosley, Cindy Abney, Judy Smelser, Linda Burke, Ann Blakely, Christine Dunmire, Linda Gustin, and Deidra Palmer. (Linda Castor.)

The Pendleton Irishettes get ready for their flight to Miami Beach, Florida, for the 1965 USTA Nationals. (Linda Castor.)

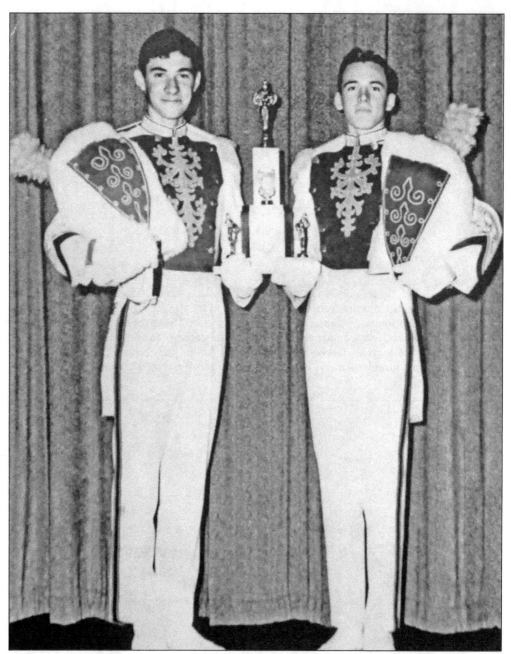

Bill Jones and Doran Purkey, drum majors for the Pendleton High Marching Irish, proudly display the 10th place trophy won at the 1964 Indiana State Fair Band Day. The Marching Irish first performed at the Indiana State Fair Band Day in 1955, when the school tied for 28th place. The Marching Irish broke the top 20 in 1963, finishing 18th out of 87 competing schools. The last Indiana State Fair Band Day appearance by Pendleton High School was in 1968. The Marching Irish finished 24th that year.

Trevor Junga keeps a steady beat with the Pendleton Heights Marching Arabian drum line while keeping a watchful eye on the drum major at the 2005 Indiana State Fair Band Day. (David Humphrey.)

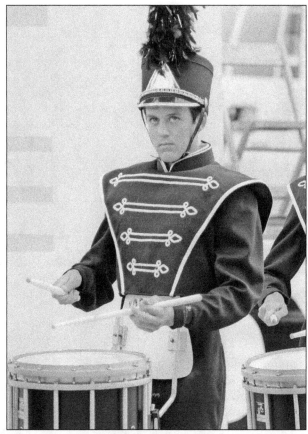

Trumpeter Dillon Smith performs with the Pendleton Heights Marching Arabians at the 2005 Indiana State Fair Band Day. Pendleton Heights placed 15th at the popular summer event. In 2007 and 2008, Pendleton Heights placed 9th and 11th, respectively, with 2008 being the last year the Marching Arabians competed at Indiana State Fair Band Day. (David Humphrey.)

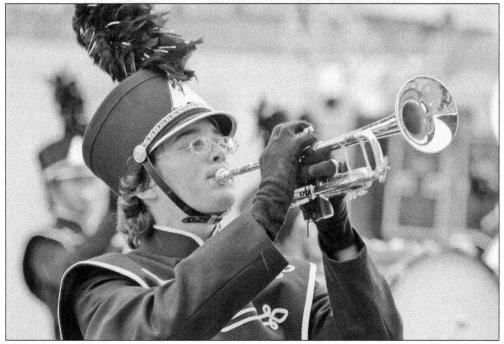

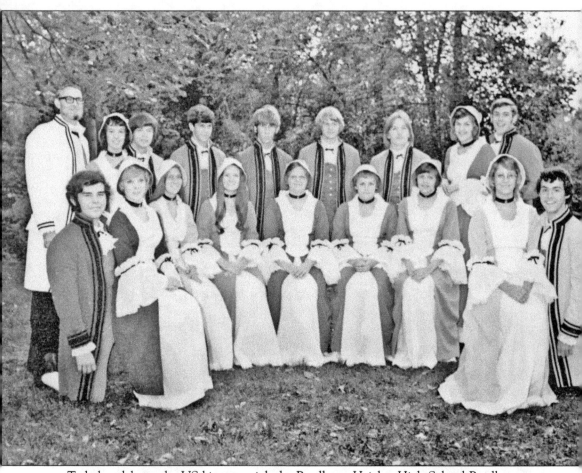

To help celebrate the US bicentennial, the Pendleton Heights High School Pendletones wore authentic 1776 costumes. The Pendletones programs in 1976 were under the direction of Sam McKean. From left to right are (first row) Fred Leonard, Marsha Fleck, Lisa McClure, Margie Giering, Judy Schleilbaum, Ellen Williams, Shirley Fatzinger, Jodi Stickler, and Greg Barkdull; (second row) director Sam McKean, accompanist Kathy Woodbury, Steve Lackey, Scott Reeve, Jeff Mathison, David Grile, Jeff Creason, Melinda Widener, and Dan Kasdorf. (Pendleton Community Public Library.)

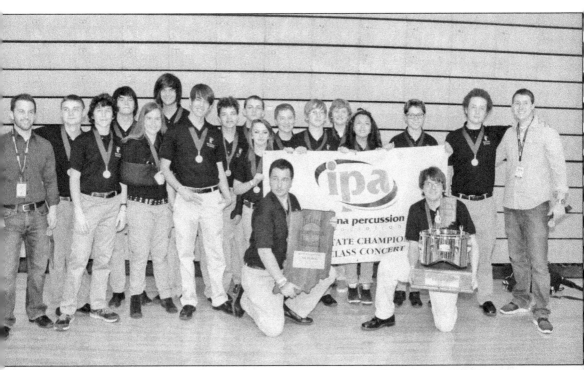

In 2014, the Pendleton Heights Indoor Percussion ensemble won first place in the Indiana Percussion Association state finals. The group of talented musicians competed in Concert Class A and earned a score of 94.4 from the judges. From left to right are (standing) Indoor Percussion director Adam Brosman, Ethan Callen, Evan Humphrey, Nick Knowles, Neeli Kasdorf, Damian Hyde, Dylan Alder, Justin Hatfield, Will Westbrook, Katye McDole, Beau Mabrey, Christopher Nixon, Garrett Lilley, Tammy Hong, Madison Rich, Andrew Weinert, and Indoor Percussion assistant Elliot Fogo; (kneeling) Curtis Silvey and Payne Hannah. (David Humphrey.)

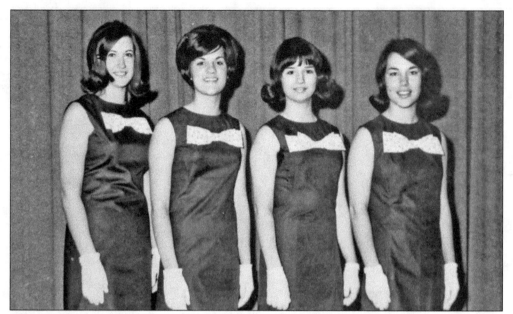

The 1967 version of the Pendleton High Musettes singing group entertained the Pendleton community on many occasions. From left to right are Lana Burke, Judy Anderson, Beth Morris, and Joyce Blair.

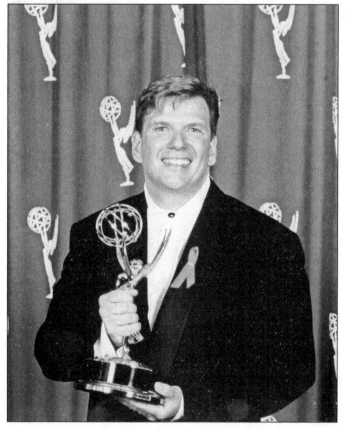

Pendleton-born George Daugherty won an Emmy Award in 1996 as executive producer of *Peter and the Wolf* for ABC. The production combined live action and animation to tell Sergei Prokofiev's musical tale and featured animated characters designed by the legendary Chuck Jones of Warner Bros.' *Looney Tunes* fame. Upon graduating from Pendleton Heights High School, Daugherty studied music at Butler University's Jordan College of Music before continuing his studies at Indiana University. In 1975, at the age of 20, he founded his first orchestra, the Pendleton Festival Symphony. Daugherty is the great-great-great-grandson of American poet Henry Wadsworth Longfellow.

Six

SPORTS

From 1921 through 1927, Lloyd
Stoner and Everett Keesling served
as yell leaders for the Pendleton
Irish basketball teams.

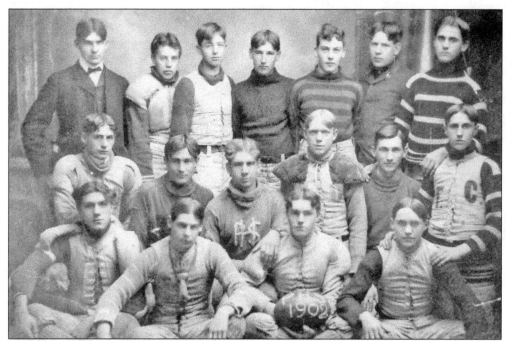

In 1902, Pendleton High School had a football team with a 16-player roster and a manager. From left to right are (first row) Herman Pritchard, Frank McVaugh, Chester Garrison, and Frank Hardy; (second row) Walter Stidham, Ray Brooks, John L. Thomas, Newton Kramer, Grover Schull, and Wes Shepard; (third row) unidentified manager, Walter Lewis, Isaac Jones, Edward Humbles, Chester Anderson, Harry Wright, and Morris Lukens.

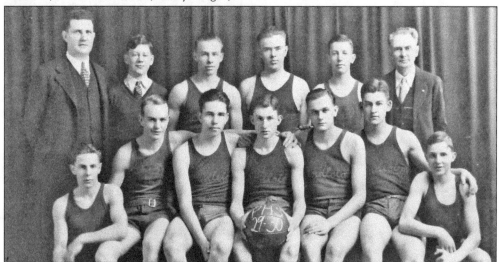

The 1929–1930 Pendleton High School boys' basketball team had a record of 12 wins and 7 losses. The varsity team was coached by Don Carter. The highlight of the season was the Irish winning the Knightstown Invitational Tournament. During the first game, the Irish defeated Cadiz by a score of 26-13, followed by a 32-18 win over Wilkinson. In the championship game, Pendleton High was victorious against Maxwell, 26-17. As an everlasting memory, names of Irish players in the tournament were engraved on the winning cup, including Jesse Hite, Elmer Anson, Vincent Lennen, Harold Owens, Harold Hoppes, Harold Anson, John Alley, and James Mannon.

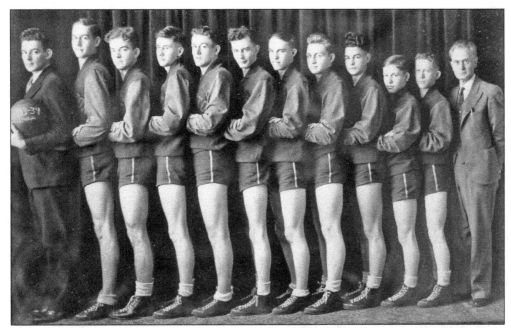

The Pendleton High 1933–1934 basketball team, pictured from left to right, are coach Ed Johnson, Weldon Smelser, Joe Swain, Jimmy Moore, Orville Stanley, Paul Hensley, Bill Smith, Carl Thomas, Rex Chamberlain, Jay Anson, Red Stevens, and principal Irvin Ellsworth.

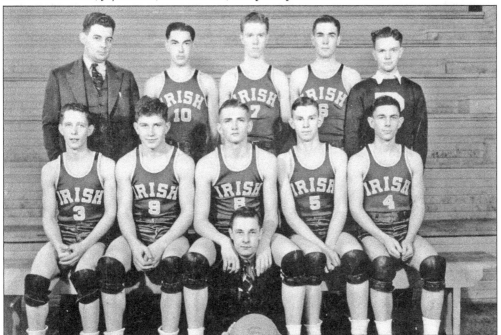

Led by seniors Charles "Henry" Clark, John "Clabber" Clark, and Hugh Smith, the 1939–1940 Fighting Irish finished the season with a record of 11 wins and 8 losses, defeating Markleville, Fortville, and Hagerstown in the final three games of the season. In the Anderson Sectional, Pendleton defeated the highly favored Elwood Panthers before losing to Alexandria in the semifinal game. (Jeanette Isbell.)

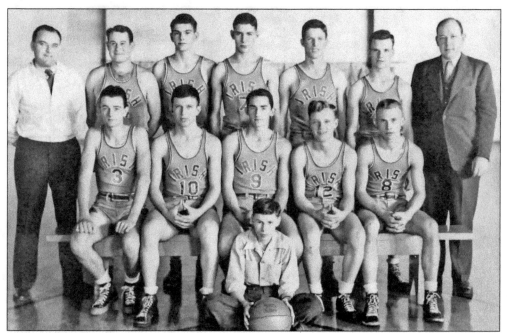

In this 1946–1947 Pendleton Irish first team photograph, from left to right are (first row) Alvin McCarty, Dick Goff, Marvin Harvey, Gene Crosley, Darrell Maitlen, and student manager Donald Crull; (second row) coach Charles Steidle, Bob Brandenburg, Kenneth Michael, Jim Schug, Rex Clendenen, Jack Crosley, and assistant coach Gail Grabill. (Jack Crosley.)

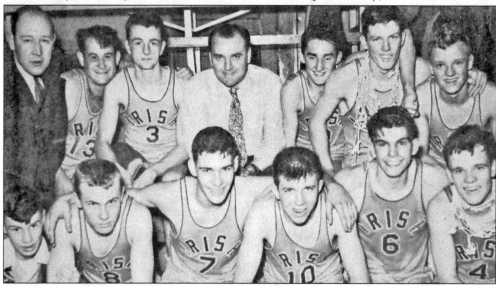

The 1946–1947 Fighting Irish were victorious in the Anderson Sectional and Indianapolis Regional. In game one of the sectional, the Irish defeated Summitville 43-34, then went on to beat the Frankton Eagles 42-33. The Irish claimed the sectional title with a 43-39 win over the Anderson Indians. At the Indianapolis Regional, the Irish beat Clayton in the afternoon game 55-44. That night, Pendleton was crowned regional champs with a 51-46 victory over Southport. At the semi-state, the Pendleton Irish lost a heartbreaker to Lawrenceburg, 45-41, ending the team's outstanding season. (Jack Crosley.)

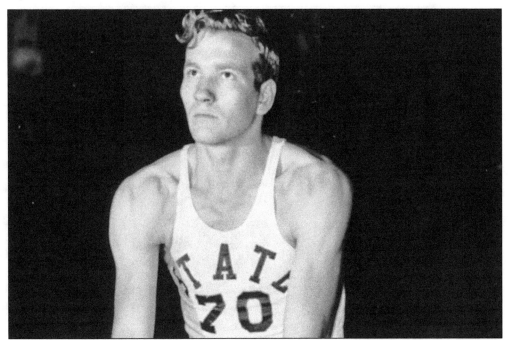

In 1944, Dick Dickey graduated from Pendleton High School, where he was a three-year starter for the boys' basketball team. After graduation, he attended North Carolina State, where he played for Hall of Fame coach Everett Case. While there, Dickey scored 1,644 points. He remains the eighth-highest scorer in the school's history. Dickey was a member of the North Carolina State team that played in the 1950 NCAA Final Four tournament. His No. 70 was retired in 1999, and he was voted one of the five most valuable players in the history of North Carolina State basketball. Though Dickey is best known for his years at North Carolina State, he also played professional basketball for the Anderson Packers and the Boston Celtics. In 2005, Dickey was inducted into the Indiana Basketball Hall of Fame in New Castle. (Indiana Basketball Hall of Fame.)

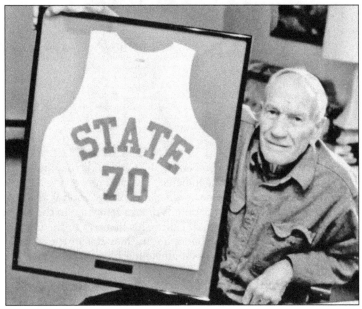

Dick Dickey is pictured with his retired No. 70 basketball jersey. (Indiana Basketball Hall of Fame.)

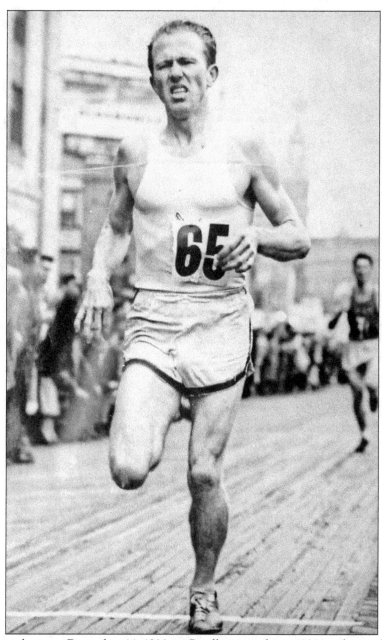

Fred Wilt was born on December 14, 1920, in Pendleton, and is a 1938 graduate of Pendleton High School. While attending Indiana University, he won the NCAA two-mile and cross-country titles in 1941. After serving in the US Navy during World War II, he began a 30-year career with the Federal Bureau of Investigation. Wilt also competed in the 1948 and 1952 Summer Olympic Games in London and Helsinki. During his first trip to the Olympics, Wilt placed 11th in the 10,000-meter run. Four years later, he finished 21st in the same event. He won the James E. Sullivan Memorial Award for best amateur athlete in the United States in 1950. In 1981, Wilt was inducted into the National Track and Field Hall of Fame. He was the women's cross-country and track-and-field coach at Purdue University until 1990, and died on September 5, 1994, in the city of Anderson.

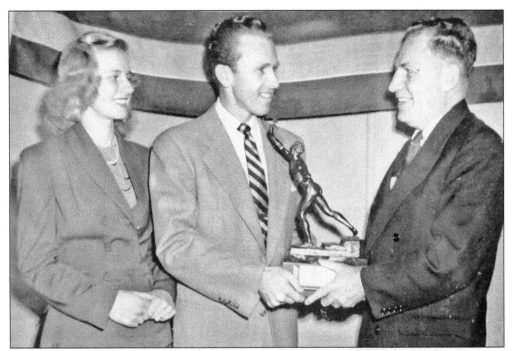

Fred Wilt receives a 10,000 meter runner-up medal from Prince Philip of Great Britain on behalf of the Amateur Athletic Union of the United States.

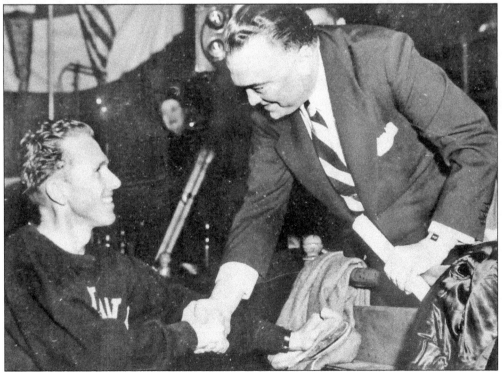

Fred Wilt shakes hands with J. Edgar Hoover at Madison Square Garden in New York City on January 22, 1953.

The Pendleton Youth Baseball League was founded by Raymond E. Hoppes. The first Little League games were played in the spring of 1954, at the ballpark near Falls Park on Falls Park Drive. Through the years, the league continued to grow, with games now being played at the Pendleton Sports Complex just east of Falls Park. A monument in memory of Raymond E. Hoppes (1923–2000) stands at the site of the old ballpark. (Jay Brown.)

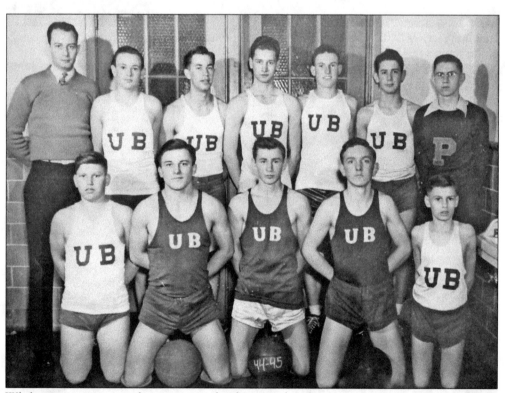

While many youngsters play sports at school, many also choose to participate in their church leagues. Seen here is the 1944–1945 Pendleton Christian Church boys basketball team. From left to right are (first row) Bob Manship, Richard Somers, John Jarrett, Hugh Jones, and David Crull; (second row) coach Paul Hensley, John Smith, Hubert Jones, Jack Bingaman, John Manship, Marvin Shelton, and manager Robert Crull.

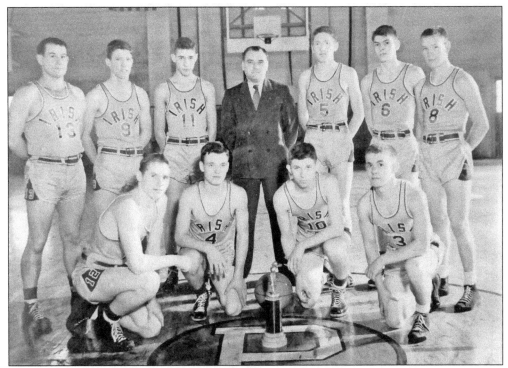

Pendleton High School won the 1946 Pendleton Invitational basketball tournament by defeating Markelville 33-23 and Middletown 31-19 in the championship game. The Fighting Irish ended the season with 10 wins and 7 losses. From left to right are (first row) Carl Crull, Jack Crosley, Dick Goff, and Rex Southard; (second row) Bob Brandenburg, Pete Clendenen, Jim Schug, Coach Steidle, Tom Harvey, Kenny Michael, and Jim Jacobs.

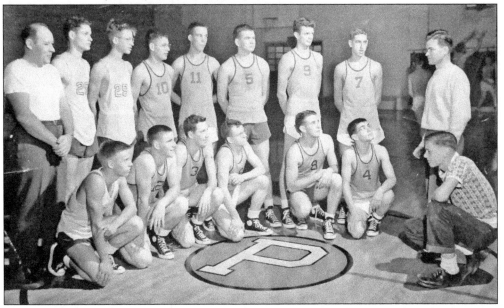

The Pendleton High Fighting Irish listen to coach Don Casterline during an after-school practice during the 1949–1950 basketball season. (Jack Crosley.)

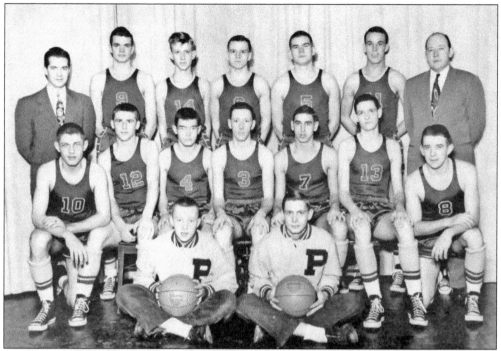

The 1949–1950 Pendleton High boys' basketball team ended the season with 16 victories out of their 20-game schedule. The Fighting Irish scored a total of 991 points, while their opponents tallied 788. From left to right are (first row) student managers Bob Redick and Paul Ayers; (second row) Harlod Dillon, Jim Wilson, Haines House, Don Gorden, Junior Howard, Charles Jones, and Joe Keesling; (third row) coach Don Casterline, Jack Milner, Phillip Boller, Jim Crosley, Bob Taylor, Jerry Hite, and assistant coach Gail Grabill. (Jack Crosley.)

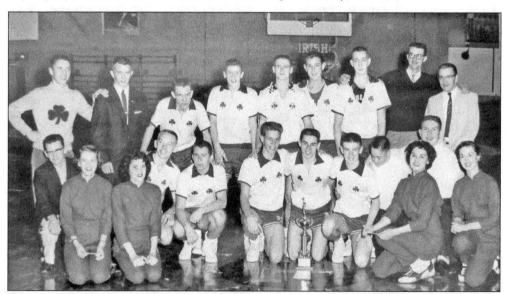

In 1957, the Pendleton High Irish were crowned Pendleton Invitational Tourney champions. In the tournament, the Irish defeated Markleville 65-63 and went on to beat Wilkinson in the title game 50-34. The Irish finished the season with a record of 8 wins and 12 losses.

Pendleton High School graduate Mike Hanna was Indiana's state pole-vault champion in 1963, and the first Indiana high school athlete to vault 14 feet. He is also the only Pendleton High School athlete to ever win a state championship. After graduating from Pendleton High, Hanna attended Indiana State University, where he continued to set records as an athlete. While at Indiana State, he was a three-time collegiate state champion and was named NAIA All-American in 1965. Two years later, Hanna was an NCAA College Division national champion, the first Indiana State athlete to achieve that status. He is a member of the Indiana Track and Cross Country Coaches Hall of Fame and the Indiana State University Athletic Hall of Fame. (Mike Hanna.)

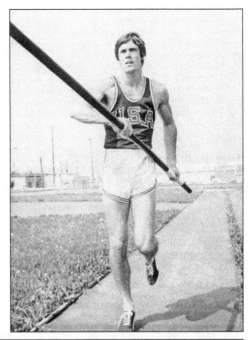

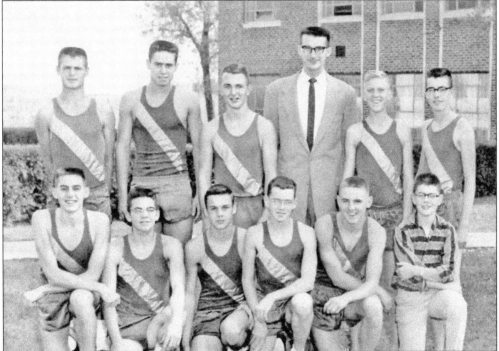

The Pendleton High School 1956 boys' cross-country team won the White River Conference meet held at Edgewood Golf Course in Anderson. The date for the meet was October 25. Middletown was the only school to defeat Pendleton High during the cross-country season. From left to right are (first row) Asa Edwards, Danny Walters, Wendell Green, Howard Leahy, Paul Edwards, and an unidentified student manager; (second row) Bill Crosley, Mike Murphy, David Rector, Coach Demich, Robert Ellis, and Bob Leahy.

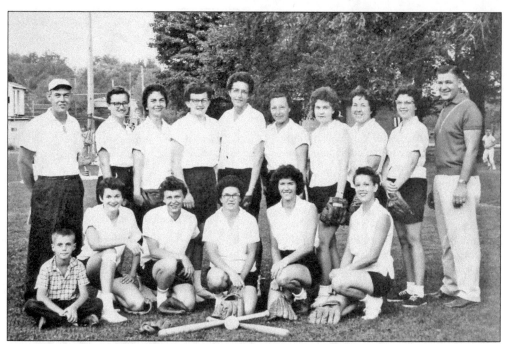

In 1961, the town of Pendleton had its first girls' softball team. From left to right are (first row) batboy Chris Poore, Sue Lineberry, Marsha Sloan, Wilma Eiler, Pat Montgomery, and Mary Ann McNutt; (second row) Bill Montgomery, Carolyn Johnson, Lil Poor, Renne Ann Slack, Jean Burkholder, unidentified, Jean Cook, Joanna Summers, Annie Brown, and Johnny Brown.

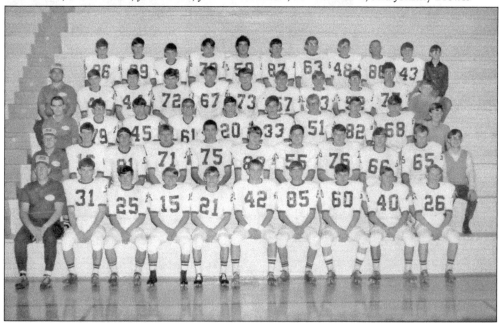

During the 1968 football season, the Irish had a record of three wins, five losses, and two ties under the leadership of coaches Dave Torrence, Jim Burrell, Barrett Bates, and Edgar Poole. This was to be the last Pendleton High football team before the opening of Pendleton Heights High School.

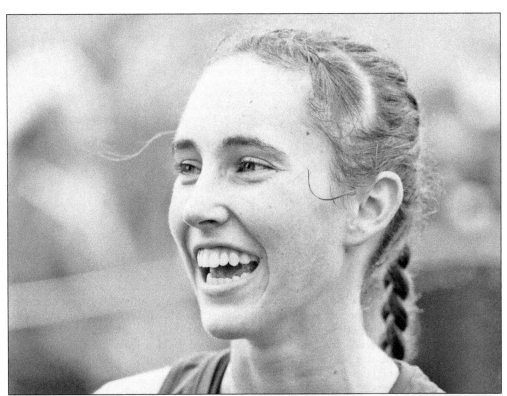

Alex Buck ran track and cross-country for four years at Pendleton Heights High School. At the 2015 IHSAA New Haven Semi-State cross country meet, Buck took home first-place individual honors. She helped Pendleton Heights to the IHSAA cross country state finals three years running, from 2013 through 2015, and was named to the All-State team in 2013 and 2014. In track, Buck qualified for the IHSAA state finals in 2013, 2014, and 2016, where she competed in the 3200 meters. At the 2016 IHSAA state track meet, Buck placed first in the 3200. She is currently a student at the University of New Mexico. (Anderson *Herald Bulletin*.)

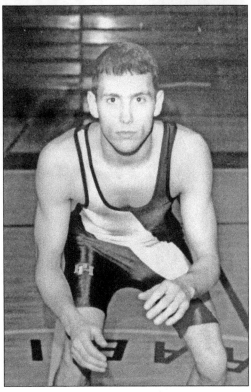

Pendleton Heights High School wrestler Donny Sands was the 1997 IHSAA state finals wrestling champion in the 145-pound division. During his senior year, Sands had a record of 35 wins and 3 losses. At the 1997 state finals, he defeated Joey Strausburg of Center Grove High School by a score of 8-4. (Pendleton Heights High School.)

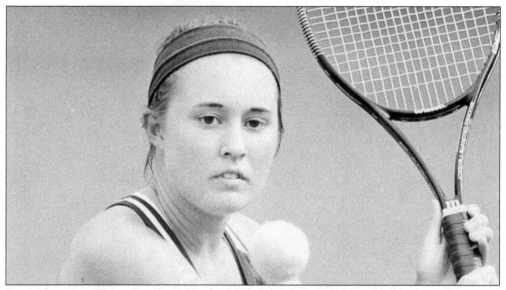

During her senior year at Pendleton Heights High School, Emma McCardwell had a perfect record of 21 wins and no losses. She was crowned champion at the Mount Vernon Tennis Sectional, followed by a regional title at Fishers High School. The regional win allowed McCardwell to advance to the 2016 IHSAA girls' tennis singles state finals held at Park Tudor High School. McCardwell's perfect season came to an end at the state finals, where she was defeated by Kristi Tinsley of Lake Central High School. (Anderson *Herald Bulletin*.)

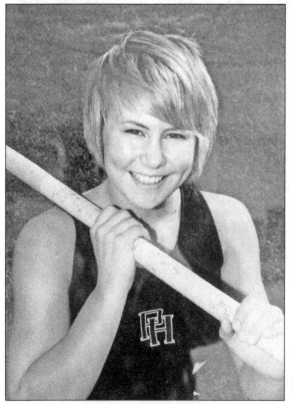

Pendleton Heights track-and-field star Ellie McCardwell was crowned champion in the pole-vault at the 2009 and 2010 IHSAA track and field state finals held at Indiana University. From 2008 through 2010, McCardwell was selected to the All-State Track and Field team and was named the 2010 Gatorade Indiana Track and Field Athlete of the Year. McCardwell is a graduate of Stanford University. (Pendleton Heights High School.)

Pendleton Heights basketball standout Kellen Dunham set several school scoring records and was named the number three player for the 2012 Indiana All-Star team. After graduating from Pendleton Heights, Dunham attended Butler University and played on the Bulldogs basketball team. During his four years on the team, he scored 1,946 points and had a scoring average of over 14 points. Dunham was named to the 2014–2015 All-Big East first team and 2013–2014 All-Big East second team. As a senior, Dunham was the recipient of the Big East men's basketball Scholar-Athlete Award. (Pendleton Heights High School.)

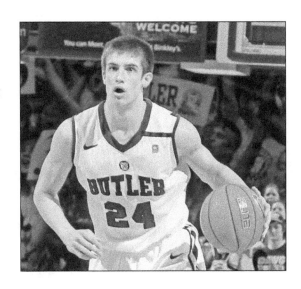

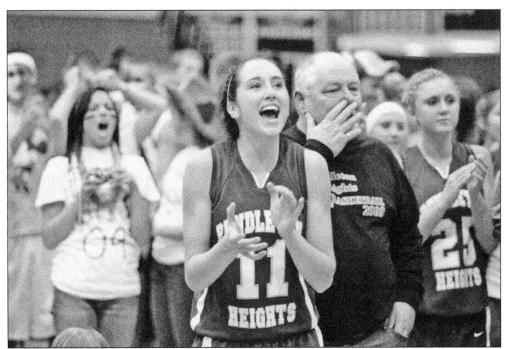

Pendleton Heights sophomore Hannah Douglas celebrates after the Pendleton Heights girls' basketball team captured the 2009 Huntington North Class 4A Regional. In the championship game, the Arabians defeated Fort Wayne South by a score of 50-40. Douglas scored 21 points in the contest. During her four years as a member of the Pendleton Heights girls' basketball team, Douglas scored 1,141 points and was named to the 2011 Senior All-State team. (David Humphrey.)

Visit us at
arcadiapublishing.com

Printed in the USA
CPSIA information can be obtained
at www.ICGtesting.com
LVHW082034151123
763818LV00008B/660

9 781540 227188